HANDMADE
PRINTS

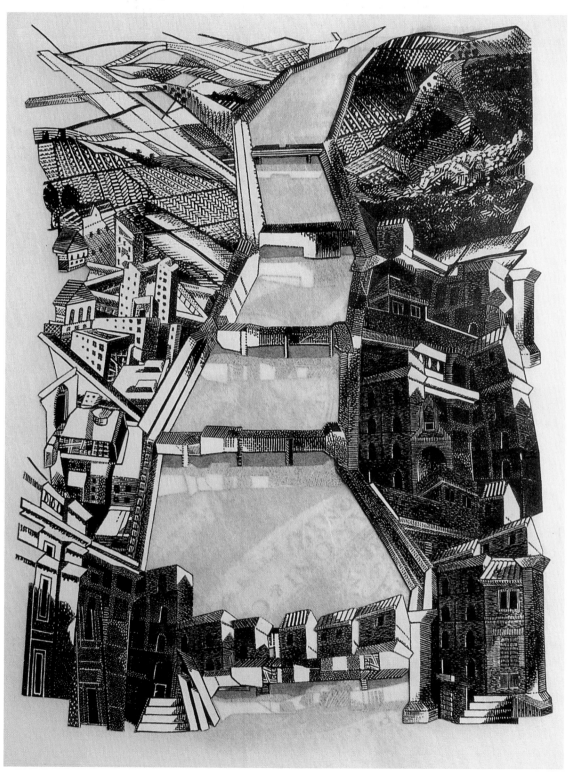

Above *'Il fiume e i ponti', 220 x 170 x 6 mm, by Anne Desmet. Collage made of pieces of the artist's wood engravings (printed on Basingwerk parchment – a smooth, ivory-coloured paper) and Amaretti wrappers collaged onto the front and reverse of a semi-transparent Japanese paper.*

HANDMADE PRINTS

An introduction to creative printmaking without a press

Anne Desmet
&
Jim Anderson

Davis Publications
Worcester, Massachusetts

For Thomas

Published in 2000 by Davis Publications, Inc.
50 Portland Street, Worcester, MA 01608, USA

Reprinted 2002

by arrangement with

A & C Black (Publishers) Limited,
35 Bedford Row, London WC1R 4JH, UK
ISBN 87192-546-X

Designed by Michael Leaman Design Partnership
Front cover design by Dorothy Moir
Front cover illustrations: Carolyn Abbott; Jim Anderson; Anne Desmet;
Louisa Desmet; Caroline Glicksman; Fiona Hamley
Back cover illustrations: Dale Devereux Barker; Anne Desmet

Printed and Bound in Singapore by Tien Wah Press Ltd

Publishers note: Printmaking can sometimes involve the use of
dangerous substances and sharp tools.
Always follow the manufacturer's instructions and store chemicals and inks
(clearly labelled) out of the reach of children.
All information herein is believed to be accurate. However, neither the authors
nor the publishers can accept any legal liability for errors or omissions.

Contents

Below *Half an onion, inked with a brush and printed by hand-pressure. (The freshly cut onion was left to dry out for about half a day before inking and printing.)*

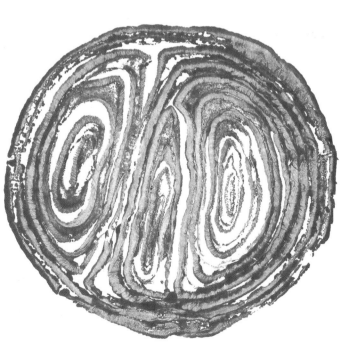

Introduction

Printmaking is often wrongly considered to be a relative newcomer at the feast of artforms. In fact, having existed since the first dinosaur left an impression of its foot in wet clay, or since a caveman's soot-stained hand left its grimy mark on a rock wall, it is arguably the host at the table. So how does printmaking differ from other ways of image-making? In essence, it is the art of transferring an impression from one object onto the surface of another – rather than directly painting or drawing a mark.

Archaeological discoveries show that carved stones, baked clay, wood and metal stamps have been used since prehistoric times to impress images onto damp clay, leather, soft metals and even human skin. This early realisation that such a stamp, inked with colour and hand-pressed on to a surface, could leave a printed impression of itself was the simple but revolutionary starting-point for the development of the printed page of text and hence the speedy communication of knowledge and the expansion of civilisation. Its many creative applications also gave rise to the ever-evolving artform that is printmaking today.

Methods which involve the use of a printing block (or some other form of re-inkable printing matrix) can be used to produce multiple versions of the same image. The potential for each impression to be identical to its fellows led to the development of the limited edition print. The possibility of accurately replicating the same picture also hugely expanded the scope of pattern-making. In addition, the potential for using the same matrix to print non-identical, experimental compositions or colour variants, or of combining different print methods within a single image, are areas in which possibilities for image-making are seemingly endless. Printmaking offers a multiplicity of means of making memorable images – every method has its own distinct character, making each one worth investigating.

Amongst this diversity of techniques, there are many which can be carried out easily, cheaply and effectively on the kitchen table at home. They do not necessarily require the specialized equipment that one might imagine and can be carried out, to wonderful effect, with varying degrees of expertise, by anyone at all: from experienced professional artists to small children; or from art students developing career skills to those wishing to develop this artform as a pastime.

With printmaking, it is possible to create images arguably more inventive and unusual than those produced by pencil or paintbrush. Prints can vary from the crisp starkness of a sparsely-cut black and white linocut – to the rococo elaborations of a multi-coloured, textured, patterned collagraph. You can also print on many different

surfaces including paper, card, fabric, ceramics, glass or wood. The art of print, as well as having numerous applications in art and craft contexts, can be seen daily in the design of cereal packets to shampoo bottles, or margarine tubs to T-shirts. Printed material is everywhere and fine prints can be made from all sorts of unexpected, everyday materials – such as potatoes, tree-leaves, bottle-tops, cardboard and string.

In this book we offer an introduction to a range of print techniques – both well-established processes and some more unusual but effective variations. What they have in common is that all require fairly basic equipment – most of which you may already have in your home and the rest of which can be acquired relatively cheaply from art and craft or DIY shops. They can all be carried out by hand, without a printing press. We aim to show how even the most basic methods can be used to make highly ambitious work. To this end, examples of prints by children are reproduced alongside those by professional artists, stressing how the technical means are the same even if the results are quite different. Our intention is to provide a diverse source of ideas for creative printmaking – ideas which can be carried out straight away, on a small budget and with no technical obstacles. The resulting prints could be immensely satisfying ends in themselves or they could provide a positive starting-point for the further exploration and development of printmaking's rich possibilities.

Below *Handprints by Thomas Willingham (age 18 months) using finger-paint applied with a sponge pad.*

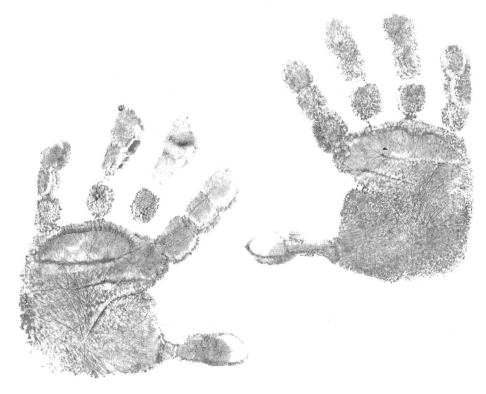

1 Equipment & materials

To carry out most techniques in this book, you will need:

- a kitchen table or other clean, flat surface to work on
- a stack of old newspapers – to protect your work surface from ink and for cleaning up after printing
- a bag of clean rags and/or paper kitchen towel – for cleaning up
- an inking slab – such as a smooth sheet of perspex, vinyl, glass, metal or marble, ideally at least 305 x 203 mm (12" x 8") and, if using glass, it should be of a toughened variety with smooth edges to avoid danger of breakage or cuts; alternatively, use a clean, metal, baking tray, a smooth ceramic tile or a melamine or formica-covered kitchen chopping board
- ink or paint (see page 9)
- paper (see page 11)
- a metal spatula or blunt, smooth-edged knife
- scissors or sharp craft knife or scalpel
- a roll of sticky tape (masking tape, ideally – but other equivalents will do)
- marker or felt-tip pens
- pencil, eraser and a few cheap children's paint brushes
- an apron (or old clothes)
- barrier cream (to protect your hands)
- washing-up liquid or soap and water
- ordinary cooking (vegetable) oil – an excellent alternative to white spirit for cleaning up oil-based inks
- clean, empty, plastic food pots – for mixing inks
- teaspoon and/or wooden spoon
- a domestic sponge
- tracing paper
- a collection of bits and pieces which can be used as printers: buttons; bits of wood; string; cardboard etc. The following chapters should give you some ideas
- a roller/brayer of at least 100 mm wide x 25 or 50 mm diameter (4" wide x 1" or 2" diameter). A roller is not required for all printing techniques but is useful for many. The most satisfactory variety is a polyurethane or soft rubber roller mounted in a metal frame and finished with a wooden handle; this is certainly the most expensive single item in the list, available only from specialist printmaking suppliers, but it is strongly recommended if you intend to pursue printmaking as a long-term commitment. Inexpensive hard rubber rollers (with plastic handles) are available from many general art and craft shops; these are harder to use successfully but are adequate for relatively basic

techniques where the printing blocks are fairly small and uncomplicated (such as potato or pipe–cleaner blocks). Alternatively, if you intend to develop the Japanese approach to woodblock printing, pigments can be mixed and blocks inked with special brushes – without using a roller at all.

To prolong the life of a roller, never leave it resting on the rubber or polyurethane part as it will develop a flat strip that cannot be removed.
Either rest it on its back or insert a screw-eye into the end of the handle so you can hang it from a hook when you are not using it.

Please note: for some of the techniques covered, you will need a few additional, specialised materials which are itemised separately, in the relevant chapters.

INK

Although it is possible to produce good prints with poster paint, watercolour, gouache, or extended acrylic paint, purpose-made printing inks are often easier to use and may produce better results. There are many different kinds available which are all either water-based or oil-based in composition. Each type has its own particular characteristics. As printmakers ourselves, we tend to favour oil-based inks for printing our own images. This preference is a result of our art education in the 1980s, in Britain, where oil-based inks were much more widely used and more sophisticated than their water-based counterparts. For centuries, however, water-based inks have been the norm in Japan – home of some of the most subtly printed, exquisite woodblocks ever made. In recent years, in western countries, advances in the technology of water-based inks have rendered them much more versatile. These developments continue and we would recommend anyone starting out in printmaking to develop an affinity with them. There are some methods for which a specific type of ink, oil or water-based, is recommended and for screenprinting, fabric printing, ceramic printing and marbling you will need particular inks which are described in the relevant chapters.

Water-based ink: pros and cons

Water-based ink is easier to wash off skin, clothes and work surfaces than oil-based and is usually removable with water. Some varieties become waterproof once dry so, if possible, wash them off while they are still wet. Note that some colours – especially reds – may stain and are not necessarily readily cleanable. Water-based ink can be used for most but not all of the techniques in this book, for instance, wood engraving blocks should not be inked with it as the surface of the wood will swell. These inks tend to dry out quickly, once out of the bottle

or tube, especially (with the brands we have tried) red hues. You can dramatically remedy this by mixing a couple of drops of washing-up liquid with the ink (on the inking slab) before printing. Also, papers printed with water-based ink can cockle as the ink dries. To prevent or reduce this tendency, when the ink is nearly dry, interleave the printed papers with tissue paper or silicone-release paper (ordinary kitchen baking parchment is usually a silicone-release paper to which the slightly damp ink will not stick) and stack them in a neat pile on a flat surface with a sheet of thick blotting paper at the top and bottom of the stack. Place heavy books on top of the pile to completely cover the paper and leave to dry for up to a week. The necessity for this and its degree of success will depend both on the type of ink and paper used. It may also help to dampen the non-printed side of each sheet of paper (by misting it with water from a plant spray) before weighing it down. Generally speaking, the thicker the paper you print on, the less likely you are to have problems with paper cockling. Among the thinner, Japanese, tissue-like papers, some such as *Shoji* (a white paper suitable for both relief and screenprinting processes) are specifically designed to take water-based inks and seem to cockle very little, if at all.

Below *The side of a toy car inked, using a roller, with water-based ink. It was printed by simple hand-pressure then re-inked and re-printed many times to create a frieze.*

Oil-based ink: pros and cons

Oil-based ink must be cleaned up either with a small amount of solvent (white spirit) and/or household vegetable oil. It cannot be easily cleaned off clothes. Oil-based inks can be used for most but not all of the techniques in this book. They are not, for instance, suitable for printing freshly cut potato blocks as they do not adhere properly to the moist surface of the vegetable. These inks generally dry much more slowly than water-based varieties which means that image-production by monotype methods as well as the printing of relief blocks can be carried out in a relatively leisurely fashion with far less likelihood of the ink drying before the image is complete. These inks will not cause absorbent blocks, such as wood, to swell. Even thin papers do not usually cockle when printed with oil-based inks; this is an asset if printing multiple colours on to one sheet of paper where correct registration of printings is vital. Oil-based inks are not recommended for screen-printing as large quantities of solvents are required to clean the screens. For many of the other print methods described, oil-based ink is a viable option but it is sensible to keep any solvents used in cleaning up to a minimum.

Ink: safety, storage and cleaning

1 Wear old clothes or an apron when printing.
2 Use oil-based ink only in a well-ventilated room.
3 Replace caps on all tubes and bottles immediately after use or the ink inside will dry up.
4 If using tinned ink, after the first use, put cling-film over the top of the tin, under the lid. This will help to make a tight seal which will reduce the speed at which the ink dries out.
5 While oil-based inks are usually removed using white spirit – we recommend, instead, ordinary household cooking (vegetable) oil on a rag or paper kitchen towel, followed by further cleaning with washing-up liquid and water. This works well and removes or reduces the need for dangerous solvents. Inking surfaces, rollers, hands (but not clothes) can all be cleaned effectively in this manner.
6 After printing, use a spatula or blunt-edged knife to scrape up excess ink from the slab. Scrape it off on to old newspaper and dispose of it carefully. Wipe the knife clean on newspaper, rags or kitchen roll. Clean the remainder of the ink from slab and roller (as described above) for oil-based inks or with a rag moistened with water for water-based inks.
7 Never use a knife to scrape ink off a roller as this can damage the roller; and be careful to clean off ink splashes from its sides and frame. Basic cleaning of the roller can be carried out with newspaper and/or paper towel but final cleaning should be done with a cotton rag to remove any paper fibres sticking to it.
8 Never clean your hands with white spirit as, with repeated use, it can cause severe dry, cracked skin conditions and skin can become sensitized to it, leading to allergic reactions from further usage. Instead, apply barrier cream to your hands before printing. You will then find that ink (whether oil or water-based) will wash off the skin easily with ordinary soap and water.

PAPER

You will need plenty of paper to print on. For most of the techniques described, you will get better results with soft, smooth, absorbent papers rather than heavily textured varieties; avoid papers with a very smooth, shiny, hard finish as these tend to repel ink. Here are some which are easily available and well worth trying if you are printing on a low budget (take note, however, that cheaper papers are usually made from wood pulp which is acidic and can cause paper to brown and become brittle with age and/or exposure to sunlight):

plain newsprint (this can be bought cheaply from art materials' shops); typing/photocopier paper (white and coloured); cartridge paper; brown wrapping paper; tissue paper (any colour); sugar paper (any colour); subtly patterned giftwrap (for added pattern/texture under your own printing); and wallpaper lining paper.

There are many specialist printing papers. They are not essential to achieve satisfactory results but papers of good quality often seem to take better impressions than do cheaper alternatives. We advise you to try some out. High quality papers are often made with cotton fibres or purified wood pulp and are acid-free (look for descriptions saying 'lignin-free' or 'cotton acid-free'). They are less prone to the ageing problems associated with cheaper papers. Some are more expensive or more decorative than others and a good art materials' supplier should be able to give you advice and a large choice: make it clear that you will be printing without a press as some papers are better suited than others for this approach to printing. Specialist printmaking papers have an absorbent surface which holds the viscous ink and pulls it away from the block or plate. Smooth, pure, unsized (waterleaf) paper is a good choice for relief printing, especially in multiple layers of colour, as ink is readily absorbed into it. Alternatively, with some papers, *size* is incorporated into the paper pulp, binding it together, but it is not applied to the surface as this would prevent the ink from penetrating. This is known as 'internal sizing' and gives the paper added strength to withstand the rigours of all kinds of printing (particularly intaglio printing when paper is usually soaked or dampened prior to printing in a press). Paper can be made with varying surfaces: *HP* (hot pressed) which is very smooth and ideal for relief printing; *rough* which has a coarse texture more suited to broad, expressive, textural watercolour painting than to printmaking; and *Not* or *CP* (cold pressed) – a general-purpose paper with a light texture. Each of these surfaces is produced by different manufacturing processes. In general, HP papers are the most suitable for the print processes described in this book but bear in mind that taking an unorthodox approach and happening upon chance effects with rough or textured papers can be a fortuitous source of inspiration.

Choices of paper are very particular to each individual and artists practising the same print process often use widely divergent papers. Choosing the right paper can be crucial in achieving the intended result. We suggest you try out a selection to discover your own preferences but, to get you started, here are some of our favourites: *Hodomura*; *Hosho*; *China White* (laid); *Kozu shi*; *Tonasawa*, *Tengujo*, *Tosa Washi* and *Shoji* are all somewhat tissue-like but deceptively strong Japanese papers which take excellent hand-burnished relief prints of most varieties. Most of these papers are thin enough to enable you, usefully, to see the image

appearing through the back of the paper as you burnish. They also stick securely to the inked block which substantially reduces the likelihood of the paper slipping and the image being blurred during burnishing. With heavier weight papers, burnishing must be done carefully to avoid the danger of paper slippage during printing.

Gampi Vellum is a heavier weight Japanese paper available in white or neutral (creamy beige). It has a sheen like shot silk and takes good monotypes; it is also useful for printing simple relief blocks by hand-pressure and more complex blocks by burnishing. Another heavier weight paper is *Somerset satin* (hot pressed white paper) which takes excellent monotypes and is also very good for printing small bits and pieces by simple hand pressure; with care, it can also be used for printing wood or lino blocks by burnishing. Smooth *Zerkall* (off-white, bright white or cream) also works well for relief printing, with or without a press.

Alternatively, try making your own paper.

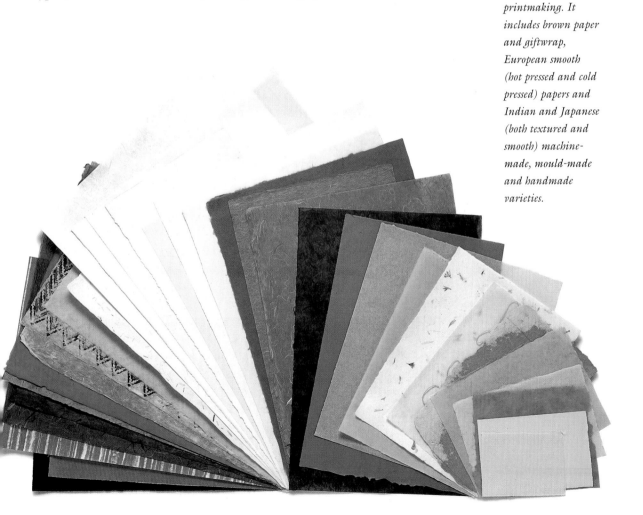

Below *A range of papers useful for printmaking. It includes brown paper and giftwrap, European smooth (hot pressed and cold pressed) papers and Indian and Japanese (both textured and smooth) machine-made, mould-made and handmade varieties.*

2 Paper-making & marbling

PAPER-MAKING

There have been many different kinds of paper produced throughout history. The Ancient Egyptians wrote and drew on papyrus which is made from a type of reed. In the Middle Ages, in Europe, vellum (made from animal skins) was used as a paper-like surface. Paper as we know it today, made from mashed plant fibres, has its origins in the Orient.

Why make your own paper? Reasons may include the following: home-made paper has qualities totally unlike shop-bought varieties; it has texture; you can incorporate your own choice of colour or pieces of matter such as dried leaves or petals (if using leaves or petals, use them thoroughly dried or pressed or they may grow mould); it is a good environmental exercise since you can recycle scrap, such as old cartridge or sugar paper; it is also fun to make.

To make paper you will need: at least two buckets (or large, old mixing bowls); lots of scrap paper (use old magazines and newspapers sparingly as they tend to produce very grey paper); a plentiful supply of water; a little wallpaper paste (available in powder form from DIY shops) or a few drops of PVA glue; poster paint; materials for 'spicing up' the paper, for example cotton thread, hair, wool, glitter, dried leaves or petals and coloured paper confetti; an old food blender (it is not advisable to use this for culinary purposes afterwards, as the paper mush is hard to clean out thoroughly) – a manual food-whisk can be used but is harder work; an apron (or old clothes), wellington boots or waterproof shoes; a kitchen spatula or flat-bladed knife; a soup ladle (or old teacup); a mesh screen (as described for screenprinting in Chapter 11: a frame with a taut mesh stretched over it – but without a backing board). If you don't have a screen and don't want to make one, you can make paper perfectly well on a piece of cloth (a piece of old bedsheet is ideal) stretched taut over any piece of flat board – such as hardboard or chipboard. If you would like to make a paper which has interesting textures on its underside, instead of stretching a bedsheet over the board try using, for instance, an old, patterned, net curtain; its weave will emboss a light texture into the underside of the paper – a sort of three-dimensional, colourless printing process. If possible, make paper outdoors as it is a messy process.

Having assembled the equipment and donned your apron and wellies, start by tearing the scrap paper into

pieces not much bigger than postage stamps. (If the pieces are too large they will not pulp down easily.) Put all the torn scraps into a bucket, filling it until it is at least half full. Then fill the bucket with water until the paper is completely covered. Leave this mixture to soak for at least a day.

The paper should now be ready to pulp. Scoop a small amount (no more than two or three tablespoons) of the soaked paper into the blender (or into a clean bucket or mixing bowl – if you intend to use a hand-whisk) and add more water to it. Add about four pints of water to one pint of paper pulp. Also add a few drops of PVA glue or a pinch of wallpaper paste. You only need a very little bit of glue or paste to help bind the paper as, if you add too much, the paper will go sticky and stiff. Also, if you want to colour it, add a few drops of poster paint at this stage. We suggest that you stick to one colour as a combination of different colours added to the pulp invariably blends to form a dirty grey or brown. Now blend (or whisk) until the mixture is completely pulverised. The pulp's consistency should resemble thin, cold porridge. Pour the newly mashed paper into a clean bucket or bowl.

Repeat this process with another small measure of soaked paper and continue until all the wet paper has

Left *Paper pulp being ladled onto a board covered with stretched sheeting.*

Right *The screen or board should be left leaning at an angle to allow the water to run off. Don't lean it at too steep an angle or the paper may run away too – especially when it is freshly made. (The paper on the board which is propped almost vertically is almost dry. The board supporting the freshly made paper is leaning at a less steep angle.) A stack of dry, finished papers can also be seen here, ready for printing.*

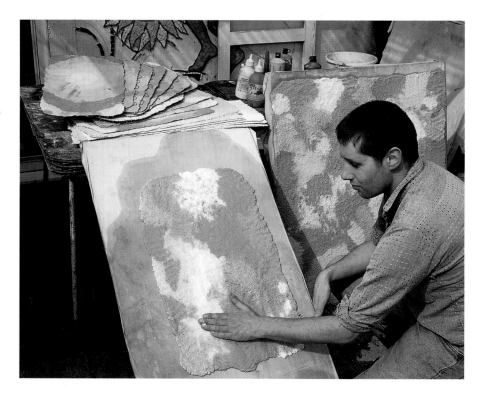

been pulped. If you are adding drops of the same paint colour to each blending, then you can simply add each newly-pulped, coloured batch of paper mush into the same clean bucket.

If you want to add a different colour of paint to each blending, you will need a separate clean receptacle for each new batch. In this way you can accumulate a 'palette' of different coloured pulps. Then take your screen (or board covered with stretched sheeting) and simply ladle pulp out onto it (with a ladle or cup) patting it flat with your hands.

If you want to incorporate extra texture, now is the time to do so: sprinkle small amounts of cotton thread, paper confetti, leaves, etc. on to the surface (use as much or as little as you like) and then pat them down gently with your fingertips so that they become half-embedded into the pulp. You can also combine ladlefuls of different coloured pulps into one piece of handmade paper.

The paper needs to be left to dry somewhere where excess water (and there will be a lot) can drain away easily. It could, for instance, be done over a bath or in a shower cubicle. But it is best, if possible, to do it outdoors on a sunny day – the paper will dry more quickly outdoors.

It will take at least a day to dry and will dry more slowly on a board than on a mesh where air can get to it both from above and below. If your paper is not dry (as it probably won't be) by the end of the day on which you make it, take it indoors overnight (leave it to drip in the

bath) and put it out in the sunshine the next day. Paper left indoors will take a lot longer to dry – perhaps as much as a week – especially if your home is cold or damp. When it is completely dry, ease it off the mesh or board with a kitchen spatula or flat knife blade. You will find that its upper surface is very textured (especially if you added leaves or fibres to it) and that the lower surface is smoother. Your finished paper may well be a decorative object in itself but you may also wish to use it for printing. Handmade paper can be especially good for use with block-printing methods such as linoprinting or woodcut. It is not appropriate for techniques such as screenprinting or wood engraving where smoother papers are required.

Below *Marbling is an easy way of making papers with organic, granular textures like marble. They can be used to print on, or for book covers or decorative end papers, amongst other uses. The red and blue piece of paper shown was made by Amy English (age 6).*

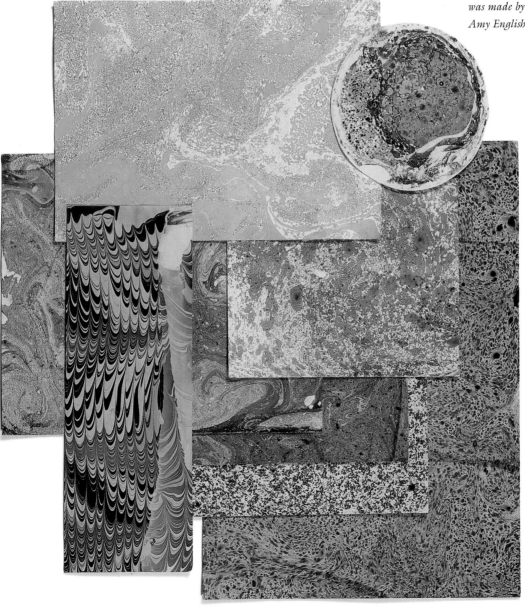

MARBLING

The marbling technique relies on the fact that oil and water do not mix. To make marbled paper you need: an old washing-up bowl (or similar) filled almost to the brim with water; oil paint or oil-based printing ink in a small selection of colours; white spirit; at least two cheap paintbrushes; at least two old saucers; paper (smooth cartridge is ideal); old newspapers; barrier cream and/or rubber gloves; rags/kitchen roll for cleaning up; and an apron or old clothes.

Protect your hands with barrier cream then mix two different colours of paint/ink – one in each saucer. Dilute the paint/ink with enough white spirit so that it pours or drips easily. Dribble both colours over the surface of the water in the bowl using a clean paintbrush for each colour. When the oil-based paint/ink hits the water's surface it will separate out into globules. You can print a piece of marbled paper directly from that surface or stir the water gently with the handle-end of a paintbrush in order to create swirling patterns. Take a sheet of paper and, holding it carefully by two opposite edges (or diagonally opposite corners), lower it gently on to the water and let it drop. Pat it down gently onto the surface to drive out air bubbles. Then gently peel the paper off the water's surface, place it (marbled side up) on a clean, dry worktop and leave it to dry. Before adding more colour to the bowl, try printing a second sheet of paper straight away – you will get a subtler (but no less beautiful) variant of your first piece. Now add a little more paint/ink to the water bath (add new colours if you wish) and continue printing. Each printing will be different from the last. Experiment with swirling the water in various ways to make different patterns – but be gentle: beware of mixing colours together to the extent that they become muddy. After marbling, sandwich the wet paper between sheets of

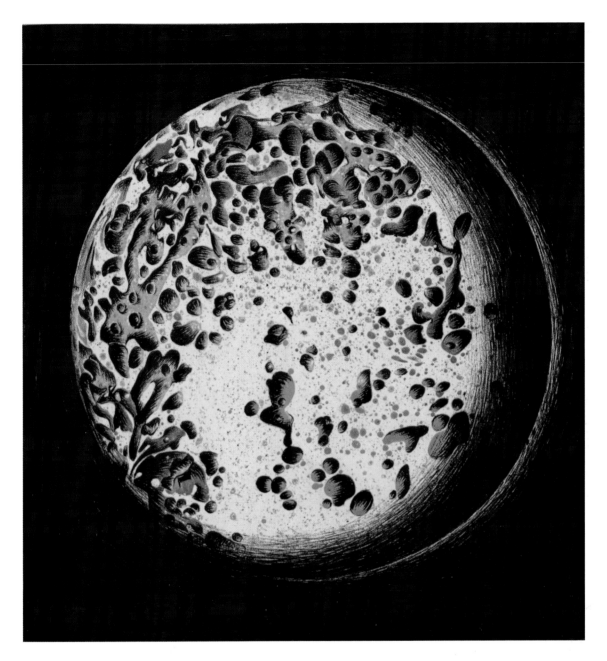

clean blotting paper laid on a flat surface and weight it down under heavy books for two or three days, so that it dries flat.

To make a circle-shaped marbled pattern (as in the 'moon' above), use a soup bowl (or similar) as your waterbath, fill it almost to the brim with water and proceed as previously described, but use paper which is bigger than the diameter of the bowl so that the marbled imprint does not fill it but prints as an isolated shape in the centre.

Above *Marbled moon, 180 x 177 mm, by Anne Desmet (at age 15). Marbled image accentuated with black pen.*

Cleaning up

Lift off as much as you can of the oil paint remaining in the bowl, by using kitchen roll or old newspaper as if you were printing marbled paper. When you have lifted off as much of the excess as you can (ie when your 'marbled' kitchen roll/newspaper comes up almost clean), dispose of the dirty paper in a sealed plastic bag in the dustbin and empty the nearly-clean water down the sink. Saucers and paint brushes should be cleaned with white spirit (or vegetable oil followed by washing-up liquid and water). *Wear rubber gloves for cleaning, to avoid getting solvent or paint on your hands.*

3 Body prints

Left *'Footprint',
220 x 170 mm,
wood engraving by
Peter Lazarov
engraved on
Bulgarian pear
wood.*

Thirty thousand years ago, prehistoric man (or woman) mixed the first ink – probably from berries, blood, animal fat and ashes from his fire – smeared it onto his hand and left imprints of his passing on the walls of his cave. *If you can ink it, you can print it*: this includes your hands or fingers –and each fingerprint is, of course, unique.

Right *'Sherlock Holmes investigates'. Pen drawing by Ken Mahood.*

NB Most water-based printing ink, like poster paint, washes off the skin relatively easily with washing-up liquid or soap and water (although a few colours can sometimes stain); if you have particularly sensitive skin you could make body prints using special, non-allergenic 'body-paints' (available in toy shops).

If you print with too much ink, you will get a blobby, solidly-printed impression. However, with only a little ink, as described, your hand or foot print will clearly show all the fine lines and patterns of your palms and soles. Try variations: printing with only the side of your hand, for example, or just heel or toes.

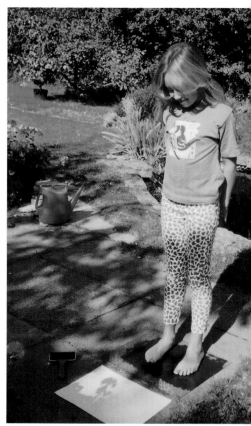

Right *To print from your feet, use a plastic or formica inking slab - as glass is dangerous to stand on. Ideally, do it outdoors, with newspapers spread about to pick up excess inky footprints. Keep a bowl or watering can with soapy water in it close by, for foot-washing.*

Try printing your hands or feet. (See Chapter 4 for inking and printing methods.) Apply some printing ink to an inking slab (you only need about twice as much ink as you would put toothpaste on your toothbrush); roll out the ink with a roller until it forms a smooth, even layer; press your hand, palm down, on to the inky surface; then press your inked hand on to a clean piece of paper which should be resting on a hard, smooth worktop, so you can press your hand down firmly, to obtain a clear print. (Alternatively, ink your hand with an inked sponge pad and print as described.)

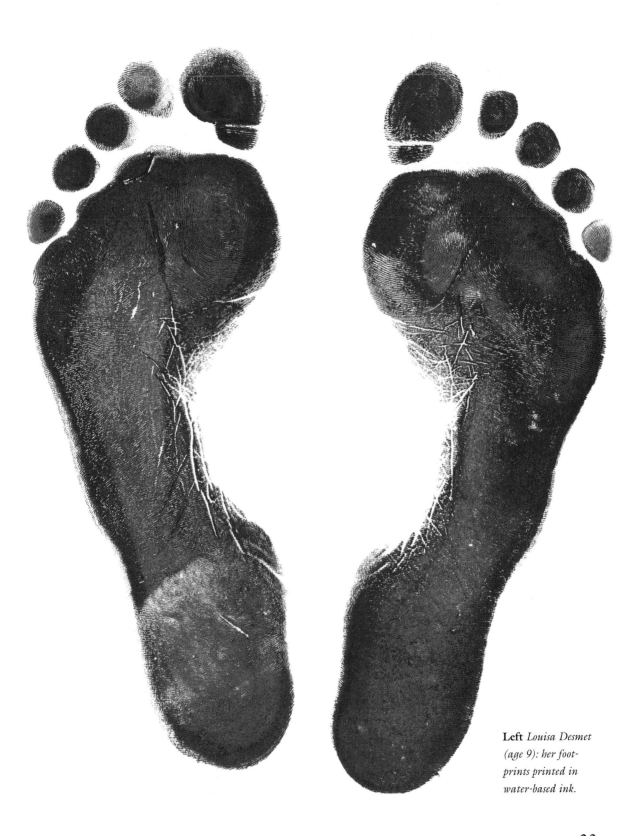

Left *Louisa Desmet (age 9): her foot-prints printed in water-based ink.*

23

4 Printing from bits & pieces

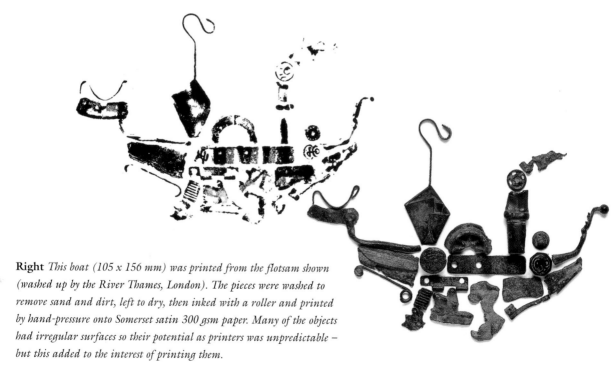

Above *This man (275 x 134 mm) was printed from ivy leaves and sliced vegetable-printers, inked with water-based paint applied with a brush and printed onto smooth card by hand-pressure.*

More or less anything with at least one reasonably flat surface can be used as a printer. Here are some suggestions: buttons; dried leaves; wine-bottle corks; wire; pipe-cleaners; paper-clips; safety pins; keys; ice-lolly sticks, the round ends of toilet-roll tubes; dried pasta; Plasticene; embossed wallpaper; coins; eggboxes; paper doilies; lids from bottles and jars; bubble-wrap; woven mesh/netting; crumpled paper or tin foil; textured fabric/lace; string; feathers; corrugated card; shapes cut from cardboard; old toothbrushes; toy cars (tops, sides and wheels); toy building bricks; sea-sponge; sea shells; sliced fruit and vegetables (eg onion, apple, cauliflower, mushroom); textured wood or bark; stone or slate; and shoe soles.

Many bits and pieces in and around your home will make excellent printers. Make a collection of them so that you have a variety to choose from. However, don't store vegetable-printers or other organic matter as they will go mouldy. You can store tree-leaves provided that they have been pressed or dried completely first.

Right *This boat (105 x 156 mm) was printed from the flotsam shown (washed up by the River Thames, London). The pieces were washed to remove sand and dirt, left to dry, then inked with a roller and printed by hand-pressure onto Somerset satin 300 gsm paper. Many of the objects had irregular surfaces so their potential as printers was unpredictable – but this added to the interest of printing them.*

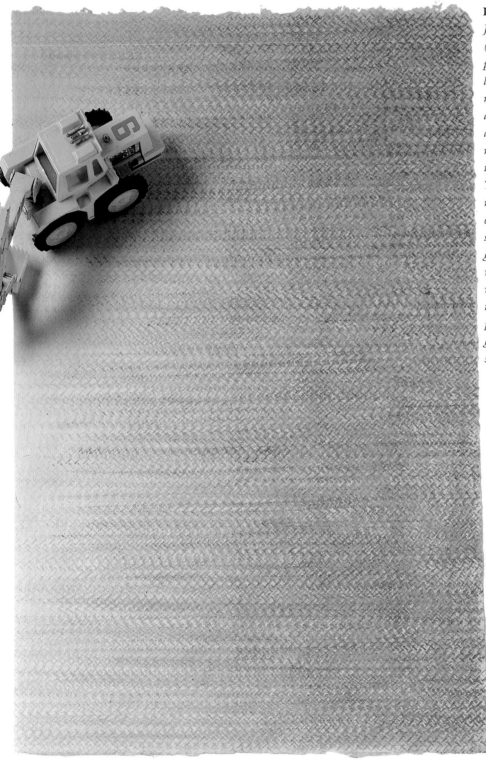

Left *This smooth Japanese paper (Kozu shi) was printed with a textile-like pattern by running the toy digger (shown) over an inked slab then running it, many times, over the paper. The toy's tyres were re-inked between each printing. Two separate shades of green oil-based ink were used; the tyres were cleaned thoroughly after the printing of the first green hue, before the second was applied.*

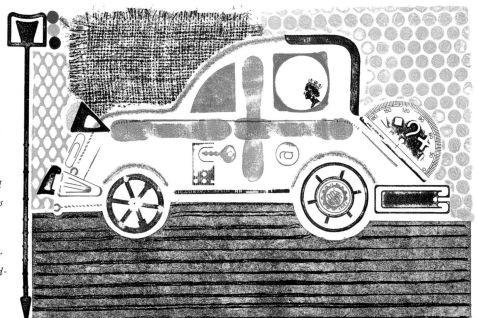

Right *'The Queen's limousine', 235 x 350 mm, by Anne Desmet, was printed from man-made bits and pieces, inked with oil-based ink applied with a roller and printed by hand-pressure onto Somerset satin 300 gsm paper.*

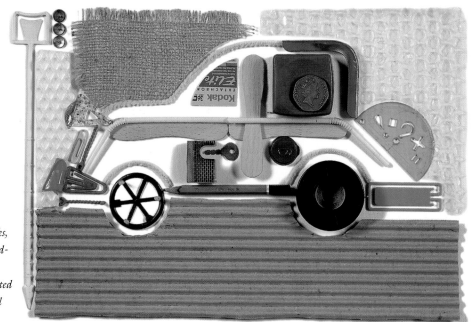

Right *The bits and pieces used as printers for the car include: ice-lolly sticks, drinking straws, card-board, pipe-cleaners, bubble-wrap, corrugated card, a coin, a pencil and a key.*

INKING & PRINTING METHODS

Printers can be inked and printed in different ways. You may find one method more suitable for printing vegetable printers and another more appropriate for printing bits of cardboard. Techniques of printing are part of your own personal, artistic process of discovery and each one will produce a slightly different result. Just as you might prefer drawing with a pencil but someone else might favour a brush – preferred inking and printing methods vary from person to person. You need to try them to discover which suit you.

Mixing inks

Start with no more than about a teaspoonful of the lightest (weakest) colour in your mix. Then add tiny amounts of any other colours required to adjust this base colour. For example, if you wish to create an olive green, start with a base of yellow and add to it minute amounts of blue to achieve a green hue and tiny quantities of red to modify the green to a more olive shade. Do not work the other way around by attempting to add light colours to darker ones as you will find you have to use wastefully large quantities of the lighter colours to influence the stronger, darker hues. Mix the ink by folding and scraping it over and over on the slab, using a reasonably flexible palette knife. Use one palette knife for mixing and a clean knife for each colour added.

When mixing inks, it is difficult to envisage how the dollop on your inking slab will look when it is thinly printed so, take a clean sample of your intended printing paper and, when you think you may have achieved the desired colour, dab a tiny blob of the colour onto the paper and spread it thin with your fingertip. Continue to dab out samples until you achieve your desired colour.

Extending inks

To achieve translucent effects of colour, it is necessary to reduce the opacity of printing inks with reducing mediums (available from printmaking suppliers). Ensure that you buy the correct variety for the type of ink you intend to use: water-based or oil-based. Reducing mediums increase the transparency of ink without changing its consistency. Where layers of reduced colours overlap, new colours are created. So, for an image involving the printing of three partially overlapping colours, you could, in fact, create a seven-colour print. Mix extended colour in the same way as described above – treating the reducing medium as the lightest or weakest hue and adding small amounts of colour to it to achieve the desired translucent ink.

Inking methods

Ink can be applied in many ways: it can be rolled on, brushed, sponged, dabbed or wiped.

The paintbrush

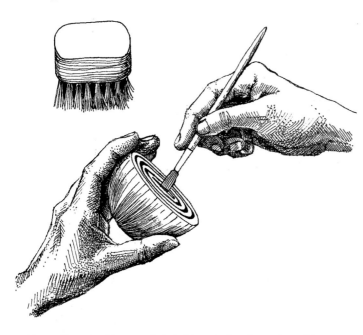

Above *Certain objects can be inked by painting the surface with a fairly soft paintbrush (preferably square-ended) – or special inking brushes traditionally used for inking Japanese woodblock prints and available from specialist printmaking suppliers. A brush is particularly useful if printing with paint instead of the stickier printing inks, or if the object to be printed is uneven in surface.*

The pounce

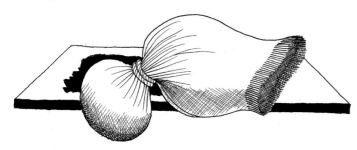

Above *Stuff a soft rag into the toe of an old, clean sock. Tie a string around the stuffed toe to make a small, soft ball. This makes a useful printing tool called a pounce (or dolly) with which you can dab ink onto the object to be printed. It is especially useful for inking small or irregular surfaces.*

The sponge pad

This is convenient and quick for inking small items: hands or fingers; household objects such as bottle tops or corks; or simple blocks such as rubber erasers or potatoes. Small inkpads can be bought from art materials' or toy shops but you can easily make your own.

You need a firm household sponge (the bigger your sponge, the more ink you will have to mix to moisten it – so use a fairly thin or small sponge), small enough to fit inside an old, clean, margarine tub (keep the lid); water-based printing ink, poster paint, watercolour or gouache; household washing-up liquid and a cheap brush or stick to mix your colour. Place a generous dessertspoonful of ink or paint into the tub and dilute with water to a consistency like single cream. (Mix whatever colour you want.) Add a few drops of washing-up liquid to the mix to stop it drying up too quickly. Moisten the sponge with water and squeeze it out so it is damp but not dripping. Press the damp sponge firmly into the ink mixture – first on one side, then the other – until it is thoroughly coloured and moistened throughout. Add more ink and water to the tub if the first batch doesn't completely moisten the sponge. When the pad is ready, take your printer and press the surface to be printed into the sponge. Lift it off and press it down onto the paper or surface to be printed.

If you want to carry on printing over a few days, seal the tub with its lid; the sponge should remain moist

for a day or two (but don't keep it too long or it may grow mould). If it dries out, mix more ink and begin again.

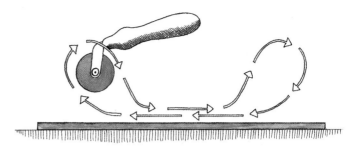

The roller

To spread ink evenly over a large flat surface, a roller (as described in Chapter 1) is a most effective tool. For inking with a roller you need a smooth inking slab, a smooth-edged knife to spread ink across the slab (like buttering bread) and printing ink. You need surprisingly little ink to start with – about the equivalent of only one or two brushings-worth of toothpaste depending on the size of your block. Add more, from time to time, as required. The ink should be about as thick as toothpaste; usually, printing ink squeezed straight from the tube is of an ideal consistency. Occasionally it may be too thick and, if water-based, may tend to dry up quickly. Both these problems can be remedied by adding one or two drops of washing-up liquid to the water-based ink on the slab and mixing it in well with a knife, before rolling. Oil-based ink can be thinned by adding a few drops of copperplate oil to the ink on the slab. If ink is too thick it will not roll out easily and if too thin it will cause the roller to skid rather than roll. Smear a dollop of ink across the slab with the knife. Take your roller and roll the ink as illustrated (above right). When the ink is rolled out evenly (which should take barely a minute) it should look like matt satin and the roller, moving across it, should make

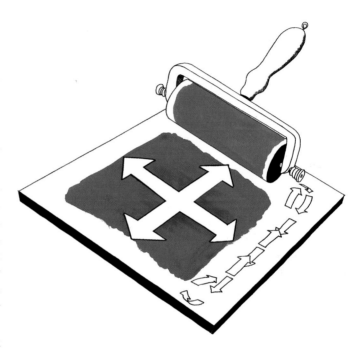

a gentle hissing rather than a loud squelching noise. Once this is achieved, it is time to roll the ink on to the printer. If this is small or will not sit flat on a work surface, hold it in your hand to roll ink on to it. If the printer is bigger and fairly flat, for instance a lino block, it will be easier to lay it on a worktop protected with newspaper and roll ink on to it. You don't need to press hard with the roller. It is better to roll lightly as excess pressure may distort a fragile block (such as,

Above *Roll the ink out evenly - lifting the roller right off the slab at the beginning and end of each revolution. This will ensure that the entire surface of the roller gets evenly inked. Roll in different directions to spread the ink evenly on the slab.*

Plasticene) or squeeze ink into delicate recesses (between veins of a leaf) which would print better if only lightly inked. Roll ink onto the block from several different directions to ensure it is evenly inked. Practice will show you how much or how little ink to apply to each printer.

Printing methods

Hand pressure

If the printer is very small – for instance a coin, bottle-top, cork or potato – it can be printed simply by pressing it, by hand, inked-side-down onto paper.

Foot pressure

This is a useful way of printing very large inked objects – such as planks of wood. To protect the floor, place lots of newspaper on to it, then place the inked printer, inked-side-up, on top. Place the printing paper carefully on top of the printer and pat it down with your fingertips. Place a large sheet of cardboard on top of the paper – to completely cover it (this is to protect it and to prevent it from slipping out of place while you are printing). Tread heavily all over the cardboard. Every now and then, lift off the board and peel up a corner of the

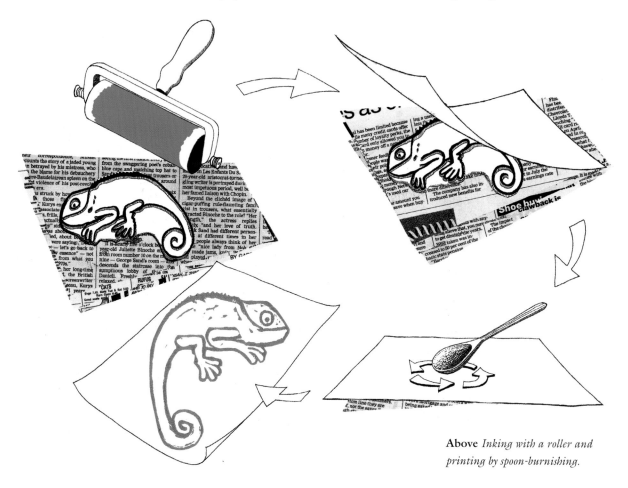

Above *Inking with a roller and printing by spoon-burnishing.*

30

Right '*Echoes II*', *200 x 180 mm, by Rebecca Salter. Woodblock print using a combination of blocks incorporating carved marks and natural wood grain. The blocks were inked using gouache applied with a traditional Japanese brush and printed by hand, onto Japanese paper, with a baren. The two halves of the image were printed separately; six to eight overprinted impressions were made on each side of the semi-transparent paper which, when dry, was laminated onto backing paper and pressed flat under weights.*

paper to see how your print is coming along. Replace the card and carry on applying foot pressure until the block is printed.

Spoon printing
(also known as hand-burnishing)
If the printer is fairly flat, lay it on a worktop protected with newspaper and roll ink onto it. Once it is inked, substitute clean newspaper for the ink-stained sheets, then lower the printing paper onto the block, patting it down gently with fingertips so that it sticks to the wet ink. Take a clean metal teaspoon, dessertspoon or smooth wooden spoon and, holding the handle with one or more fingers pressed into the spoon's bowl, rub its under-belly gently but firmly, with small circular movements, over the back of the paper to transfer ink from block to paper. (Some artists place a

second sheet of paper – often tissue or tracing paper – between the printing paper and spoon. Try this if you are tending to tear or scuff your printing paper while printing.) As you print with one hand, hold the paper in place with the other – to prevent it from slipping and blurring the picture. Every now and then, carefully peel up a corner to see if the block is printing properly. If the impression is faint, lower the paper back into place and continue rubbing. When the image is fully printed, peel off the paper taking care not to smudge the ink which may take a few hours to dry (see page 30 for illustration of this printing process).

We know of artists who use surprising spoon substitutes to achieve their handmade prints. These tools include: a rounded edge of a tobacco tin; castenets; a wood doorknob; the rounded end of a linocutting tool's handle; an alabaster egg; a glass pestle; an oriental, ceramic, rice spoon; polished stones; and specially moulded, smoothed chunks of wood.

Baren printing

The baren is the traditional tool used over many centuries in Japan for printing woodblocks. Barens are exported from Japan and are available from specialist printmaking suppliers. They vary greatly in price and quality. The average diameter of a baren is about 130 mm and, traditionally, it is constructed in three layers: there is a coil of twisted bamboo fibre on top of which is a circular pad of laminated paper; the whole thing is wrapped in bamboo sheath (a leaf-

like growth from the base of the leaf stem) and this is also twisted around at the back to make a simple handle. A baren should not get wet but does need to be oiled with a drop or two of household vegetable oil before and after printing and/or, rub it over an oiled pad during printing. The bamboo sheath tends to wear out after repeated use and will need replacing. Outside Japan, replacement sheath is not available but it is possible to improvise by covering the implement with an old sock, pulled taut. A sock-covered baren should not be oiled. It is also possible to buy strong plastic barens which are also Japanese exports. Again, they are only available from specialist suppliers and are not particularly cheap, but they offer a hard-wearing, effective printing option in the West where bamboo sheath is

Below A baren is a disc-shaped pad held in the hand and used, like spoon-printing, for burnishing the back of a print when it is laid on the inked block. (The illustration shows the back of a traditional baren, with its twisted bamboo-sheath handle, and the front of a modern baren with its numerous raised nodules of plastic).

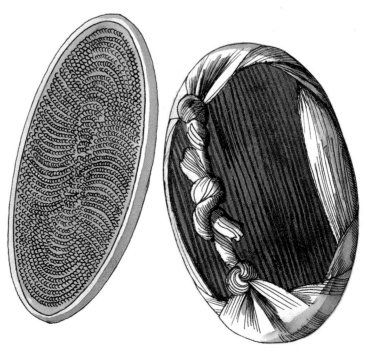

unavailable to mend a worn, traditional baren.

Barens are extremely effective for hand-printing large wood or lino blocks. The internal coil of fibre (or tiny raised nodules of plastic in the non-traditional variety) provides multiple points of contact with the back of the print when the implement is used for burnishing (as opposed to spoon-printing which provides just one point of contact). During the circular motion of printing by baren, the pressure of the hand impresses all these points of contact down onto the paper and through to the block beneath, so that multiple parts of the print are printed simultaneously. This is particularly advantageous for printing large blocks which would take much longer to spoon-print. Cheap barens are often made only from laminated layers of card wrapped in bamboo sheath. They tend to be somewhat ineffective as the card layers do not provide the vital multiple points of contact. So, don't waste your money on a cheap one.

If working to a tight budget, it is possible to make your own durable baren from a circular piece of wood to which you glue a tight coil of plastic washing line. Put this inside an old sock, pull the fabric taut across the coiled washing line and tie with a knot or string at the back (ie behind the wooden disc). The coiled washing line is a good substitute for the coil of twisted bamboo fibre and provides the required multiple points of contact between printing paper and block, during printing.

Roller printing

If your printer is large (such as a big lino or card block) it can be tiring and time-consuming to hand-burnish. If you have a second, hard, clean roller, blocks can sometimes be printed by rolling firmly over the back of the printing paper, rather than burnishing with a spoon. Hold the printing paper firmly in place while you roll, however, or the paper may slip and blur the print. As the roller applies less pressure to the block than a spoon or baren, you may find that you need to apply more ink to the block than usual to print effectively by this means. If printing an extremely large wood or linocut, a garden roller is a possible option.

Combining printing methods

You might find that some objects are best printed by a combination of methods – for instance, a small area on a large block, which refuses to respond to foot or roller pressure, can usually be burnished with a spoon. You will probably also find that your first few printings are fainter than subsquent impressions. Don't worry about this as it takes a while for the ink to build up to full strength – as certain printers may absorb some ink. If you over-ink the block and find that fine details have filled in, without re-inking the block, print three or four impressions on to old newspaper and/or press a clean pounce all over the block to lift out ink from its recessed areas.

5 Effective, inexpensive printing blocks

POTATO

The humble potato makes a versatile printer. It is best suited to bold, simple shapes as it is not easy to cut detailed designs into it. More complex results can be achieved by cutting several potato blocks and printing them in different colours and combinations. Choose a large, firm potato, wash and dry (but don't peel) it, then slice it cleanly in half. Blot any excess moisture from the cut surfaces using paper towels or a dry sponge. You now have two potato halves which can be cut with linocutting tools, or a knife, and printed.

To ink your potato block use water-based ink when the potato-cut is fresh, as the greasier oil-based ink will be repelled from the block's moist surface and will not print effectively. (Oil-based inks can be used if the newly cut potato is left for about half a day until its surface has dried – but note that the block may shrivel as it dries which may distort the image cut onto it.) Either roll its surface with printing ink, or paint it using a brush or pounce and thick poster paint, or press the block into a sponge pad. The potato can be printed by simply pressing it by hand on to paper.

Apply more ink between each printing. As you will be printing with water-based ink, you may get better results by printing on thin, smooth card as paper may cockle when drying (unless you press it flat, while it dries, under heavy books).

You can make printing blocks from other hard vegetables and fruit such as swedes, carrots, turnips or apples, using the same methods. Remember that these blocks will not store well. They will develop mould or shrivel within a day or two, so you should print them on the same day that you cut them, then throw them away.

Above *You can draw onto the flat surface of the potato using a pencil - it may not make a grey mark but should leave an indentation – a useful guide for cutting. If you make a mistake while cutting, chop off a slice from the potato, blot the damp end and start again.*

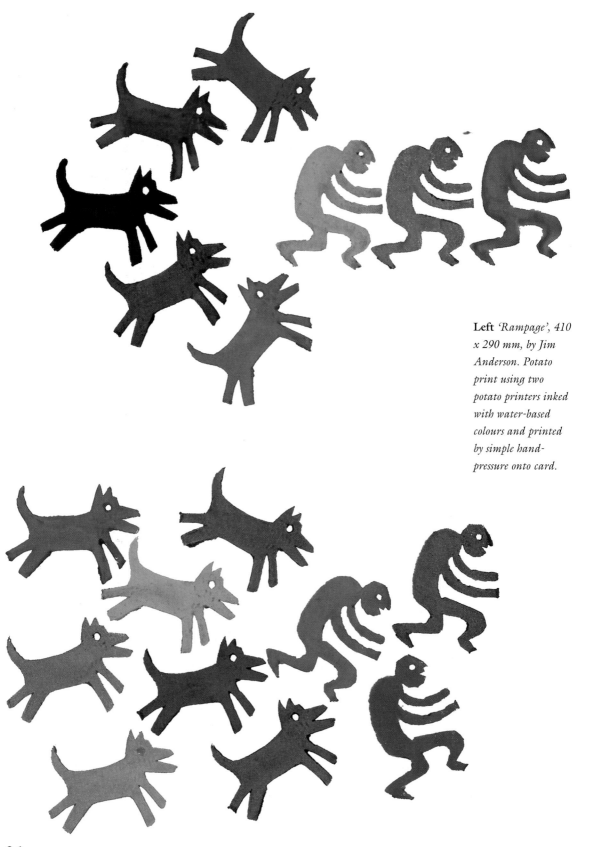

36

Important features of potato prints

These features apply to all printing blocks into which you cut an image but ink the uncut surface.

1 The print is a mirror image of the design on the potato so, if you want to cut letter or number shapes, you must draw and cut them back-to-front.

2 As the print is achieved by applying ink to the uncut flat surface of the block, the cut parts of the potato will form the 'white' areas of the image (assuming you are printing on white paper). If you want the cut parts to form the darker areas, ink the potato in a pale colour and print on darker paper.

Left *'Six Geese a-laying', 210 x 160 mm, by Sally Stephens. Monochrome potato print from one block.*

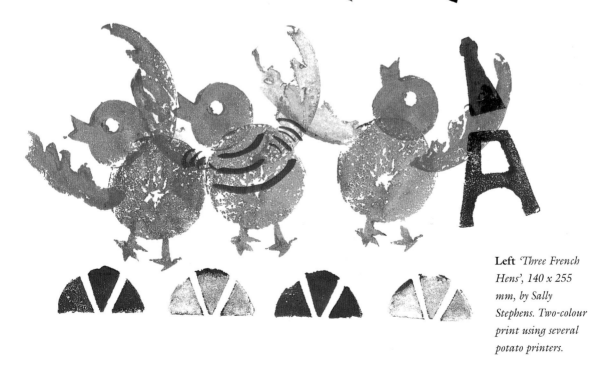

Left *'Three French Hens', 140 x 255 mm, by Sally Stephens. Two-colour print using several potato printers.*

Right *You can indent Plasticene with a slightly blunt pencil. Marks made by stabbing it with the pencil's point print as circular dots. Pressure from the handle of a teaspoon leaves broad dents. Rolling the side of a ribbed bottle-lid across the surface or impressing the block with the teeth of a comb or prongs of a fork make strong striped patterns. Blocks can also be cut with linocutting tools. This block (surface area: 96 x 114 mm) was made using most of these methods.*

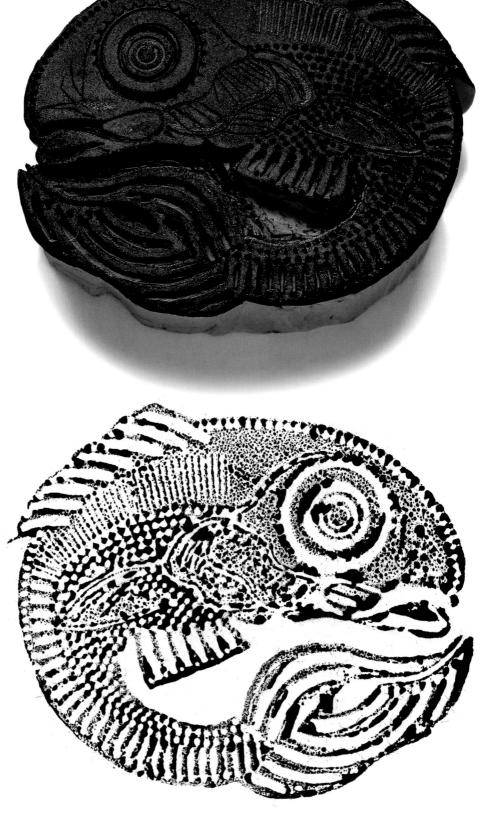

Right *Water-based ink tends to be repelled by the waxy Plasticene; it forms tiny ink droplets on the block's surface which print like this.*

38

PLASTICENE

Plasticene can be used to create distinctive, unusual printing blocks. Roll it into a large ball or mould it into a brick shape. Then flatten one surface by pressing the ball/brick firmly down on to a flat worktop. Flatten its opposite face slightly too, to enable you to place it on to a work-surface, printing face up, so it does not wobble while you are working on it. Lightly impress into its flattest surface bits and pieces such as screws, buttons, keys, bottle-tops, paper-clips, etc. These can either be left shallowly embedded and printed in this state or they can be pressed into the Plasticene then carefully removed, leaving their impressions behind. Plasticene can also be engraved with linocutting tools or indented with a pencil.

If the Plasticene is rather soft, the block can be hardened by placing it in a fridge overnight. However, as long as you don't press too hard while printing, it isn't essential to harden the block first.

Plasticene can be inked easily with a paintbrush. Care should be taken, if inking with roller or pounce, not to dent its surface. Use water-based printing ink or poster paint (oil-based ink tends to lift away from the waxy surface of the material and if you use white spirit to clean off these inks, it will dissolve the Plasticene's surface).

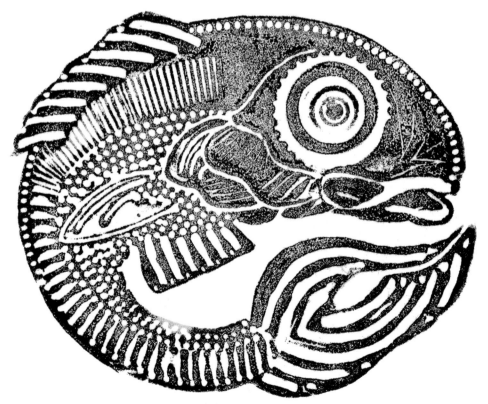

Left *When mixing water-based ink or paint, add one or two drops of washing-up liquid to it, before applying the mixture to the block. This will not only reduce the tendency of the ink to be repelled from the block but also stops it from drying out too quickly, whilst you are inking.*

Lay a sheet of smooth, thin paper (a Japanese paper such as *Kozu-shi*, plain newsprint or light-weight photocopier paper are ideal) over the inked surface of the block. Pat it down lightly so it sticks to the wet surface, then print by careful finger-pressure over the back of the paper. Be careful not to press too hard in case you distort the Plasticene's shape. If the paper is thin enough, you will see a light impression of the image appearing through the back of it as you print. This can be helpful, enabling you to see which parts of the image you have not yet printed. Once printing is complete, carefully peel the paper from the block. If treated carefully, you can obtain a surprisingly large number of prints from one Plasticene block.

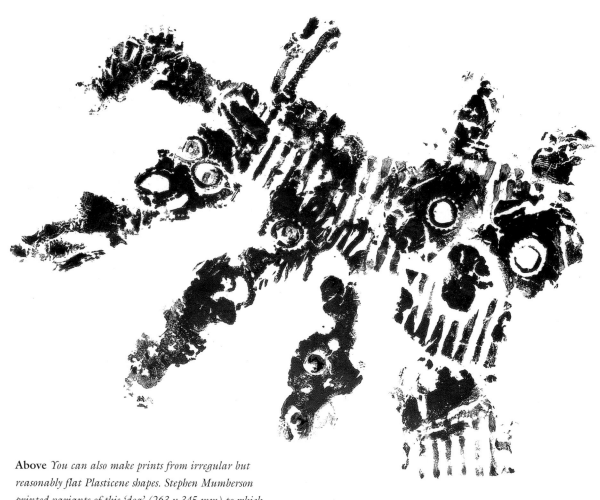

Above *You can also make prints from irregular but reasonably flat Plasticene shapes. Stephen Mumberson printed variants of this 'dog' (263 x 345 mm) to which he intentionally applied excessive pressure during printing. He then re-inked and re-printed the increasingly distorted blocks as an evolving series.*

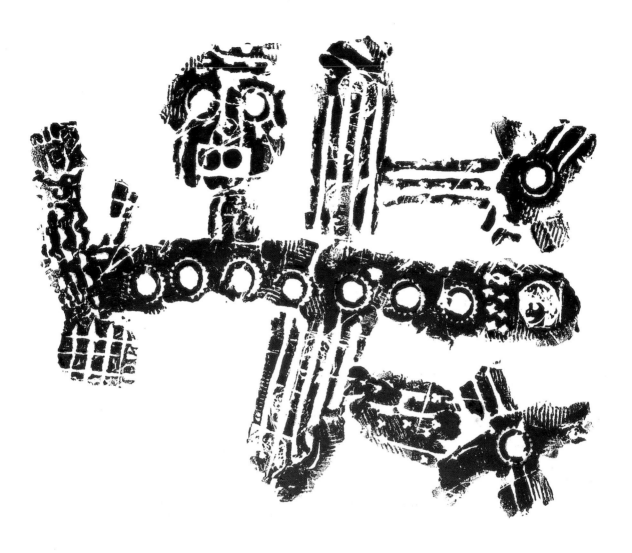

POLYMER CLAY

Polymer clay (better known by the brand names of *Fimo* and *Sculpey*) is a synthetic modelling clay which, since the 1970s, has been made and marketed for children's use. It is sold in small blocks and is widely available in art, craft and some toy shops. Rolled with a kitchen rolling pin to a depth of 3 mm, the contents of one packet can be cut up to provide a lot of small blocks or one large one of about 406 x 610 mm (16 x 24 in) – but take care not to make a block too large to fit in your household oven. It can be moulded and modelled in a very similar fashion to Plasticene. Its significant difference is that it hardens at temperatures between 110 and 140°C (225 and 275°F) – achievable in a normal domestic oven. When heated as directed (at

Above *'Aeroplane', 235 x 300 mm, Plasticene print by Stephen Mumberson. Its textures were made by indenting it with plastic children's toys, stencils, ruler, pen-top, cloth, pencil-sharpener, yoghurt pot and screwdriver blade.*

41

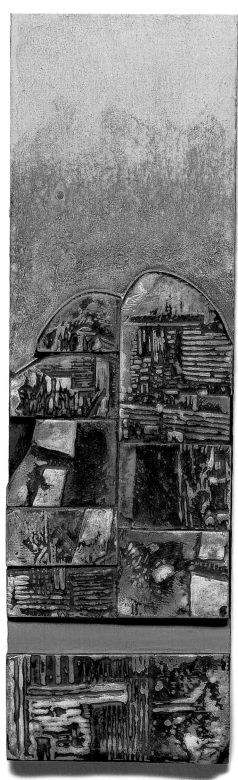

Right *Polymer clay blocks can make exquisite finished works in themselves, as bas-relief sculptures such as this: 'Rockface City and Ravine', 130 x 40 mm, by Roy Willingham. The clay blocks were indented, constructed and embellished as described for 'Precarious Red Buildings' (adjacent) but as well as being painted, the surface of the indented blocks was rolled with white oil-based printing ink.*

temperatures below 150°C/300°F) it is also certified non-toxic.

It is flexible, versatile and, once hardened, extremely durable which makes it a good material for a printing block which needs to withstand the rigours of repeated handling and printing.

The soft, unbaked clay takes minutely detailed impressions of objects such as leaves, bottle-tops, wire mesh, sandpaper etc. and you can draw into its surface by indenting it with a pencil, sharp metal nail, stylus or knitting needle. Images can be made on it exactly as described for Plasticene blocks but it is a more sensitive surface that can be used to make prints with finer marks and a wider range of textures. You can, for instance, achieve interesting tonal areas by impressing granulated sugar into the surface of the clay block, then dissolving the sugar in warm water after baking the clay. Unbaked polymer clay will also take excellent impressions of other pre-existing fine printers such as wood engraving blocks. These impressions can be used as printers themselves (they will print as reasonably accurate mirror-images of the original engraved impressions, though you should expect some variation in surface characteristics and possible slight image distortions between the clay and the woodblock prints).

To take an impression from a pre-existing block: dust the engraved surface of the pre-existing block with talcum powder or corn starch then cover it with a pre-rolled clay block of similar surface

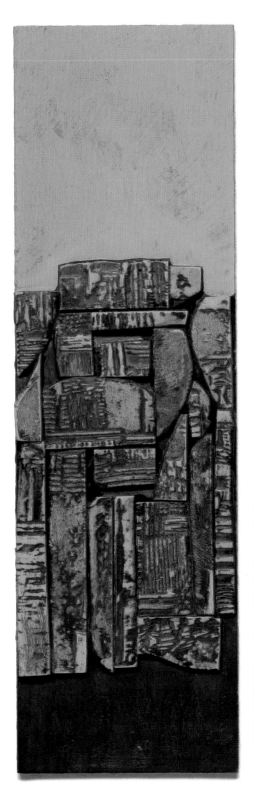

dimensions. Apply light pressure by rolling the back of the clay with a hard roller or by gentle hand pressure. Very gently ease the clay off the block and bake hard in the oven. For very finely detailed blocks, such as wood engravings, this method may not be effective as clay may be held in the fine marks of the wood block when it is lifted off. For such blocks, instead of using talc or corn starch, try laying taut clingfilm over the clay before impressing the engraving block. Then ease the clay block off the wood, gently pull off the clingfilm and bake the clay as previously described.

Preparing the clay

Before rolling it into blocks, the malleability of the clay needs to be improved to make it more pliable. Chop it into tiny pieces and work it, by hand, as if kneading bread

Left 'Precarious Red Buildings', 130 x 40 mm, by Roy Willingham, was made by pressing one of the artist's engraved wood blocks into reasonably flat pieces of polymer clay. The indented clay was baked hard then cut into irregular shapes. These pieces were assembled into a composition and glued (with PVA) to conservation mount board. They were embellished by brushing in a casein-based paint (PLAKA) to emphasise the indentations and by painting their textured surface.

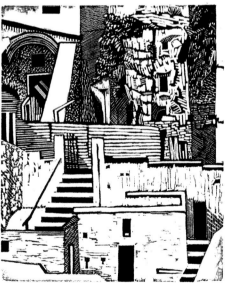

Left 'Rockface Steps', 76 x 64 mm, by Roy Willingham. The wood engraving block for this image was used to indent the polymer clay blocks comprising 'Rockface City and Ravine' and 'Precarious Red Buildings' (both illustrated).

43

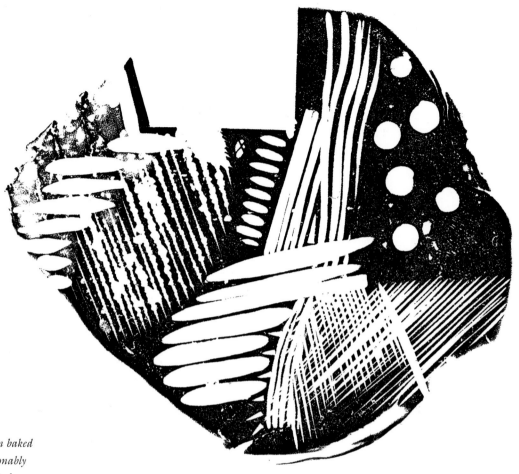

dough, until if feels softer. Protect your hands with rubber gloves or barrier cream. An electric food processor can help but should not be used subsequently for preparing food. Very slight warming, such as that achieved by leaving it on a sunny windowsill, can make it more malleable, but it is important not to let it become too warm as, being heat-sensitive, it will start to harden. Polymer clay does not harden by exposure to air so an unbaked block can be worked over a long period although it may become less malleable after about a week. (If required, soften it up again as described above.) While it remains unbaked, store it in its original wrapping since the plasticizer (which keeps it soft) will gradually leach out if the clay is left for a long time on a porous surface such as cardboard or wood.

Baking, inking and printing

Polymer clay can be baked in a household oven on a semi-rigid surface such as an old metal baking tray. The underside of the clay will take on the character of the surface

on which it is baked (with some random air pockets). This baked underside can also be used as a printing surface. To obtain a slick, shiny surface (on both sides) bake the clay sandwiched between two sheets of weighted glass or metal. Sometimes thinner blocks can tend to warp while baking. If this happens, weight them under something heavy and flat while they cool. The required baking time will vary from block to block – from 20 minutes at 104°C (220°F) to an hour at 129°C (265°F) – depending on the clay used and the desired strength of block. A higher temperature will produce a stronger block, but the harder it is, the more difficult it is to carve.

Baked polymer clay blocks can be inked with a brush, pounce or roller using oil or water-based ink and printed by spoon-burnishing onto smooth paper (such as *Somerset satin* or a Japanese tissue, *Kozu-shi*). If using oil-based ink, clean the block with vegetable oil on a rag as solvents, such as white spirit, will dissolve its surface. Alternatively, simply leave the ink to dry on the block.

Below *'Matera - 12 Architectural Details', c.160 x 210 mm by Roy Willingham. The polymer clay pieces were indented with an engraved wood block before being baked hard and painted with casein-based paint.*

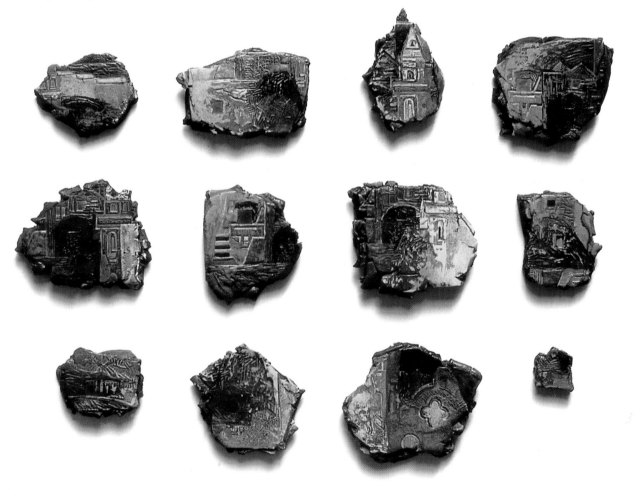

Right *'Palais pour Le Petit Prince', 285 x 170 mm, by Anne Desmet. The palace was made from a polystyrene block. It was first printed in red, further work was then carried out on the block before it was re-inked and printed in blue on top of the red. The two large planets were made from woodblocks cut by Jean Lodge, the tiny planet from an Italian coin. The yellow planets were printed on the reverse of the semi-transparent paper to give a subtler character. All parts of this print were inked with a roller and printed by spoon-burnishing.*

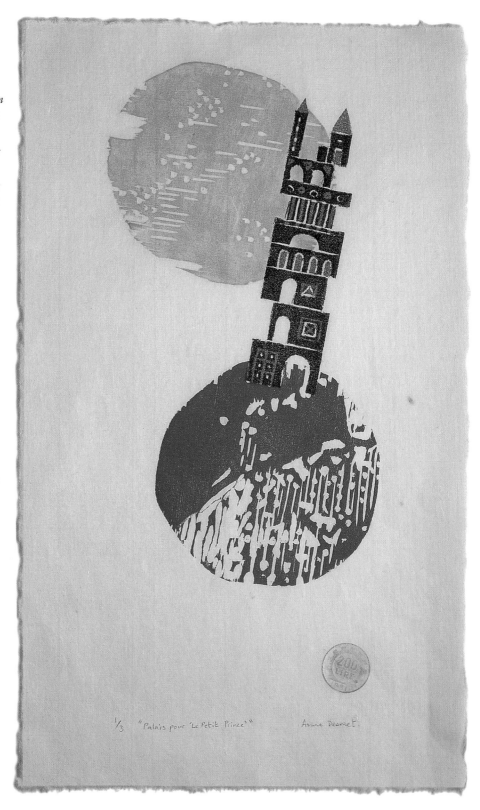

1/3 "Palais pour 'Le Petit Prince'" Anne Desmet

Plaster of Paris

Plaster of Paris can also be used to take an impression of a pre-existing printing block (such as a woodcut). These can, as described for polymer clay blocks, be used as printers themselves or they can be exquisite bas-relief sculptures in their own right. It is a well-known method but one which is not always successful. In our attempts, the brittle plaster cracked and broke before or during printing. In our opinion you can get equivalent and quicker results using polymer clay and these blocks are far less prone to fracturing; but if you find the idea of using plaster interesting, persevere and you will get a block with a very distinctive surface.

POLYSTYRENE

Blocks of polystyrene (styrofoam) make excellent printing blocks – you can create an image on any piece with a flat surface. The ideal variety is that used to make containers for take-away burgers and other fast-foods: wipe the box clean and cut out the top and bottom which make excellent, flat, rectangular, printing blocks. Big flat circular pieces are often part of the packaging of pizzas – or you can also make curved blocks from styrofoam cups. (Expanded polystyrene of the white preformed sort used for packaging electrical goods is not recommended as it is much more resistant to being indented and prints with a predominant speckled texture; this tends to overpower any image impressed upon it.)

Polystyrene printing blocks are particularly satisfying for children and anyone who has little strength in their hands for the cutting and carving employed in many other relief print processes. The blocks are quick and simple to produce and can be used to create both simple or fairly complex linear designs.

The image, consisting of marks easily indented into the block's flat surface, can be inked with a roller or brush. If using a roller, you may find during inking that the thin block tends to lift off the worktop and wrap itself around the roller. To avoid this, drip three or four drops of water on to a clean area of the inking slab and press the uninked block onto the surface. The water will help to seal the block to the slab's surface, making rolling it with ink much easier. To break the seal, slide the blade of a palette knife beneath the block. For printing, oil-based ink is more reliable, as water-based ink does not always roll well onto polystyrene – but both inks can be used successfully. Print by laying a smooth

Left The polystyrene block used to create the 'Palais pour Le Petit Prince' (far left). This shows its first stage of printing (red), before the turrets were cut off the block prior to its next (blue) printing.

Right *It is easy to draw onto polystyrene using a not-too-sharp pencil or ballpoint pen. Even the pressure of your fingernails will make a strong impression. Sharper tools, such as knives, are not recommended as you are aiming to dent rather than cut the polystyrene.*

You can also impress objects such as bottle-tops, screws, fork prongs etc into the material and combine their indentations with drawn marks on the block. Pressing a firm, straight edge (such as a ruler or edge of a post-card) into the block is an easy way to make a straight line, or you could create a textured straight line by pressing the prongs of a comb into the block.

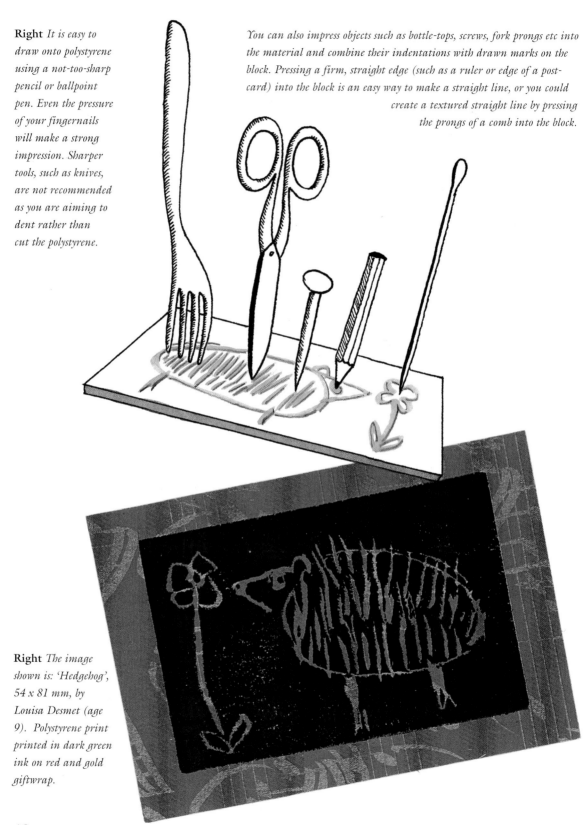

Right *The image shown is: 'Hedgehog', 54 x 81 mm, by Louisa Desmet (age 9). Polystyrene print printed in dark green ink on red and gold giftwrap.*

48

Left *The artist used scissors to cut away parts of this once rectangular block, prior to inking it with oil-based ink and printing by burnishing with a teaspoon.*

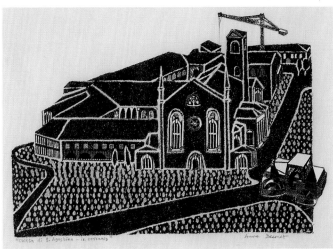

Left *'Chiesa di S. Agostino in restauro', 90 x 133 mm, by Anne Desmet. Indented dots were added to the block before reprinting. Once the ink had dried, flecks of gold leaf and fragments of wood engravings were collaged onto the print. Red paper was collaged onto the back of the semi-transparent, Japanese printing paper to create areas of tone.*

Left *Polystyrene block inked with black ink. The traces of red are from the ballpoint pen used to indent the drawing onto the block.*

Right *'Umbrian Landscape', 305 x 180 mm, by Anne Desmet. Indented plywood print printed in white oil-based ink on black paper. The sky area and receding hills were burnished more heavily than the foreground hillside to produce a stronger tone.*

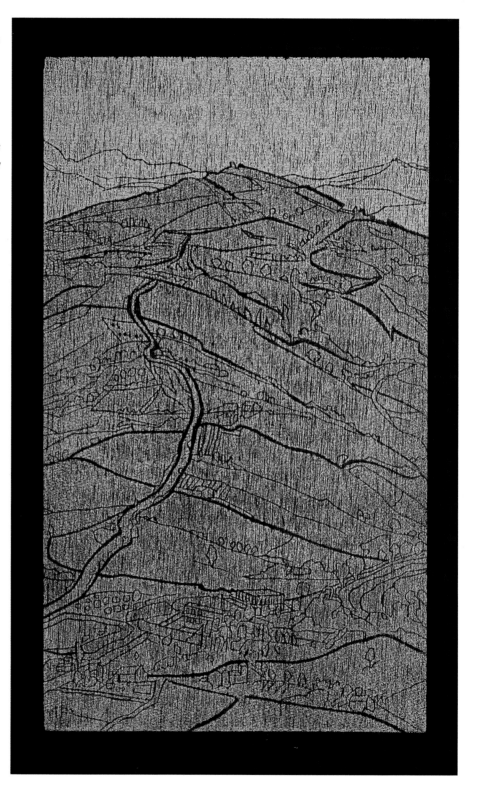

paper gently on top of the inked block. Pat it down lightly so it sticks slightly to the ink. Burnish the back of the paper with finger-tip or spoon pressure before peeling your completed print from the block.

After about ten impressions, the surface of the polystyrene can begin to decay, so each block is only useful for a fairly small number of printings.

PLYWOOD OR PINE

Prints can also be produced from harder materials – woods such as balsa, ply or pine – by using a very hard pencil, ballpoint pen, (metal) nail, reasonably sharp metal knitting needle or kebab skewer to indent a design on to the wood. The softer the wood, the easier it will be to indent. Prints made in this way have a subtle, linear quality and also, depending on the nature of the wood, its grain can print with an attractive surface texture. You can emphasise the grain by rubbing the wood with wire wool; rub in the direction of the grain to emphasize the wood's pattern. As with all the printers described thus far, your finished print will be a mirror image of the design on the block so, if incorporating letters or numbers, remember to indent them back-to-front.

Whilst the more deeply indented marks will print the most clearly, quite light indentations will also print well as long as you are careful not to apply too much ink. Lightly indented lines will probably pick up some ink so that, when printed, they will have a softer, more granular texture, like a soft pencil or pastel mark. Indented woodblocks can be printed in the same way as polystyrene ones, although they may require more pressure (spoon or baren burnishing rather than finger-tip pressure) to produce a clear impression. They can be printed either with water-based or oil-based inks. If printing with water-based ones, the wood will tend to absorb ink and swell slightly – which could obscure the image after one or two printings. So, if you just want a few prints from your indented wood block, you could use water-based ink but if you want to print several impressions it would be better to use oil-based ink. Like polystyrene prints, indented woodblocks are best printed on a smooth, absorbent paper. The surface should print as a flat area of tone or colour with a delicate pattern of the wood grain showing clearly. Remember that the indented design will not pick up ink so, if you are printing on white paper, your indented drawing will print as a white image on a coloured background. If you want the drawing to form the darker areas of the print, then ink the block in a pale colour and print on darker paper.

PLASTIC & RUBBER ERASER

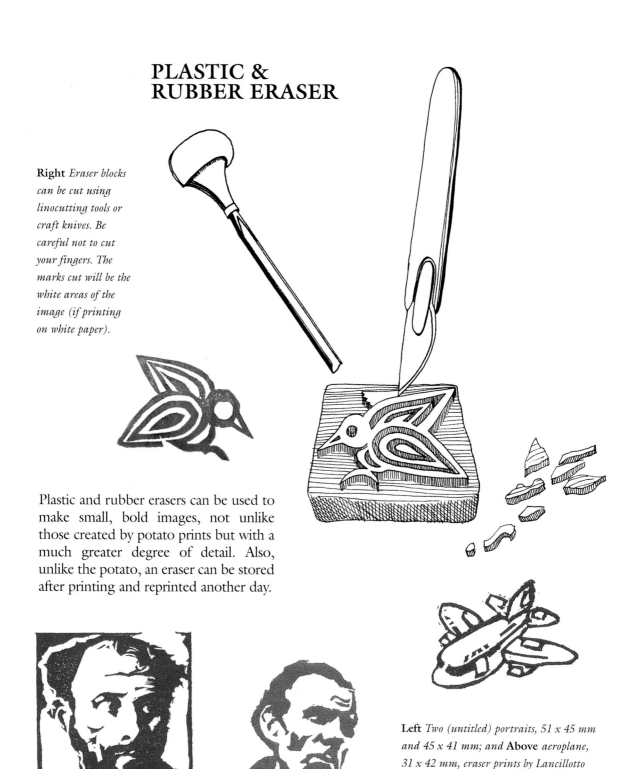

Right *Eraser blocks can be cut using linocutting tools or craft knives. Be careful not to cut your fingers. The marks cut will be the white areas of the image (if printing on white paper).*

Plastic and rubber erasers can be used to make small, bold images, not unlike those created by potato prints but with a much greater degree of detail. Also, unlike the potato, an eraser can be stored after printing and reprinted another day.

Left *Two (untitled) portraits, 51 x 45 mm and 45 x 41 mm; and **Above** aeroplane, 31 x 42 mm, eraser prints by Lancillotto Bellini. They were inked with water-based ink on a sponge pad and printed by hand-pressure.*

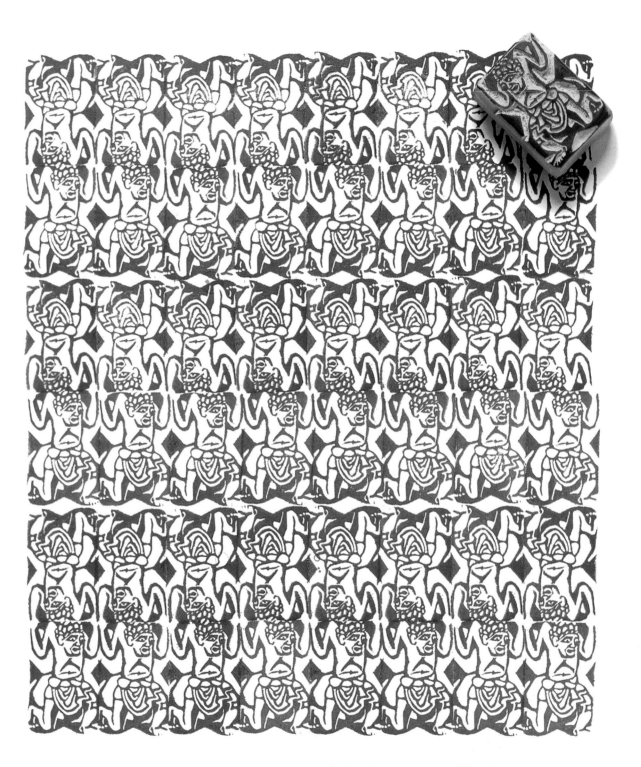

Above *Untitled repeat-pattern, 229 x 198 mm, by Anne Desmet, was created from just one rubber eraser, inked with a roller and printed by hand-pressure, pressing the eraser down onto the (Zerkall) printing paper. Registration was achieved simply by eye.*

53

Erasers can be used to create tiny printed pictures or repeat-patterns, complete in their own right, or to provide areas of small detail in a larger print produced by a different process. Choose any eraser which has at least one flat surface. It may be made either from rubber or from plastic/vinyl. The rubber erasers we tried seemed slightly easier to carve than the plastic ones – but there is little to choose – both are easily cut. Draw a design on to its flat surface using a pencil or pen. If you use a pencil and draw lightly enough, any errors in your drawing can be rubbed out by rubbing your finger or another eraser over the mistake. Remember that the final print will be a mirror-image of the design on the block, so draw and carve letters or numbers back-to-front. Engrave the eraser with linocutting tools or a sharp craft knife. Plastic erasers can be inked effectively with a roller, pounce or brush or by pressing the block into an ink-pad. The block can be printed very simply: place the printing paper or card on to a worktop, then press the inked surface, by hand, on to the paper. Don't press too hard or the printed image will tend to look coarsened. A smooth paper or light-weight card is ideal for printing erasers.

Below *An assortment of pipe-cleaner and wire printers.*

PIPE-CLEANER & WIRE

Pipe-cleaners and wire can form the basis of delicate linear prints. Different thicknesses of wire produce thicker and thinner printed lines and these provide an interesting contrast to the softer, 'furry' line created by printing a pipe-cleaner. Wire prints give a sharp, spidery line similar to a fine pen mark, whereas pipe-cleaners make a softer, more blurred line with an air-brush-like effect. Pipe-cleaners can usually be purchased from art materials suppliers, craft shops and toy stores. For the wire, use thin, plastic-clad, electrical wire which can be bent easily but will retain the shape created. This is available from DIY and hardware stores. To create a pipe-cleaner or wire printer, simply bend the material into either a single shape which will create a complete linear picture when printed or make a number of wire shapes, each of which can be printed separately, perhaps in different colours, to form a complete, more complex image. When making your printers, try to imagine each wire or pipe-cleaner as if it was a drawn line. The pressure of printing will press the printer flat so don't worry if, initially, it has slight irregularities. Small wire shapes are much easier to ink and print than larger pieces which tend not to be adequately rigid for ease of handling during the print process.

Pipe-cleaner and wire printers can be inked with a brush, pounce

Above '*Face to face*', *142 x 293 mm, by Anne Desmet. This was printed from a pipe-cleaner and wire printer, one side of which was inked and printed, the ink was allowed to dry, then its other side was inked and printed providing a mirror-image. The printer was inked with a pounce and printed by finger-pressure onto Somerset satin 300 gsm paper. The printer's wires and pipe-cleaners were connected by wound joints which did not print easily.*

55

or roller, using water-based or oil-based ink. Lay the printer on a surface (protected with newspapers) whilst applying ink. Pipe-cleaners will require several ink applications as the initial coating tends to soak into the fibres. On to a clean worktop, lay a sheet of printing paper, carefully pick up the inked printer with tweezers (or fingers) and place it, inked side down, on to the paper. Then place a sheet of tissue paper on top of the printer to completely cover it. This will prevent inky fingerprints getting on to the printing paper but, being semi-transparent, you will be able to see through it to print. Whilst holding the inked printer firmly in place (through the tissue) with one hand, apply pressure to each part of it, bit by bit, with the fingers of the other. If printing several wire printers on to the same image, allow each printed section to dry before printing the next. This avoids the danger of smudging wet ink. Alternatively, you may find it easier to print this type of printer as follows: position it on to the printing paper; place a second clean sheet of paper over the top so that the printer is sandwiched between the two; place a heavy book or piece of board over the top and press down very hard; carefully lift off the weight, the top piece of paper and the printer, to reveal the finished print.

PAPER & CARDBOARD

Ordinary cardboard and stiff paper make versatile printing blocks with different effects according to what type of card is used and what you do with it. All sorts of card types are suitable: from rough to smooth, cardboard boxes to corrugated card, cereal packets to old greetings cards. Printers can be made by simply cutting the card into shapes, each of which, inked and printed, like a jigsaw piece, forms part of the whole. Card prints can also be made from a single piece of card on which an image is drawn; its outlines are shallowly cut and the top layers of card, between each scalpel cut, can be peeled away.

Card or paper can be torn to produce interesting, textured, printed effects from the torn edges. Corrugated cardboard prints with distinctive stripes. Sandpaper prints with a dense, speckled texture. Thin card blocks can be folded or crumpled, then smoothed out – the crease-marks print as a delicate linear texture. Card blocks can be drawn on with ballpoint pen or hard pencil and the indented image can be printed. Cardboard shapes can be assembled to produce a three-dimensional illusion when printed. This illusion can be enhanced by inking each piece in a different colour or tone – to create impressions of light and shade. Having created your blocks, ink them with a roller and, if they are all of more-or-less the same height, lay them in their appropriate related

Far left 'Lunch at Atlantis', 500 x 350 mm, by Greig Burgoyne was made on a single piece of corrugated card. Some parts of the block were peeled away to reveal the corrugated texture which printed as stripes; other parts were cut away more deeply to print as white areas; other parts were scored with a sharp knife to print as white lines.

positions on a registration template*
on a worktop (protected by
newspaper) or on a clean inking
slab. You may find a pair of tweezers
helpful for picking up these thin,
inked blocks. Lay a clean sheet of
paper over the top, pat it down
gently so that it sticks slightly to
each inked block; print by spoon-
burnishing. Be careful not to knock
any blocks out of position or your
image will be blurred. If the blocks
are of different thicknesses or if you
have cut several blocks to achieve
overlapping areas of colour, you will
need to print each one separately.

If printed with oil-based ink,
cardboard blocks with a glazed
(slightly shiny) surface will successfully
withstand several ink applications.
However, we suggest you paint the
block with a thin layer of liquid
shellac varnish (available from
hardware stores and art materials'
suppliers) before inking with either
oil or water-based inks, as unglazed
card will quickly become soggy.
Once dry, this layer will act as a
sealant, enabling you to take many
impressions from the block.

***Registration: to get each block
to print in the right place, before
inking, lay the blocks in their
correct positions, with surface-
to-be-inked uppermost, on a
clean sheet of paper of the same
size as your printing paper.
(Remember that your final print
will be a mirror-image of the
shape composed.) Using a sharp
pencil or pen, carefully draw
around their outlines to create a
clear template for the image, then
remove each block for inking up.
Once the blocks are inked, simply
lay each one in its correct position
on the template and place the
printing paper carefully over the
top – ensuring that you match up
at least one of its right-angled
corners and one straight edge,
perfectly, with the outer edges of
the template paper. (Use the same
corner and straight edge to register
each print). If printing many
blocks in separate printings, this
simple registration method will
ensure that each one prints in the
correct place.**

6 Glue & collage prints

GLUE PRINTS

PVA glue (ie white glue or wood glue) can be used to create lively, distinctive images.

Protect your work-table with old newspaper before making a glue block. It is important to use water-proof glue as this will not dissolve when printed with either water-based or oil-based inks. Trail the glue onto a card block as if icing a cake. You can make indentations into the surface of the glue before it has set hard – using a nail or prongs of a fork or comb. You can also add texture by sprinkling granular substances, such as sand or coarse-ground pepper, on to the surface of the glue when it is still quite wet.

Once dry, it can be inked with a roller, brush or pounce. Alternatively,

Right *Trail the glue as if icing a cake, or smear it with stick, knife or fingers, or paint with brush onto a card block (the front or back of a cereal packet is ideal) and leave it to dry, overnight at least. The glue leaves a raised surface which, when dry, can be inked and printed.*

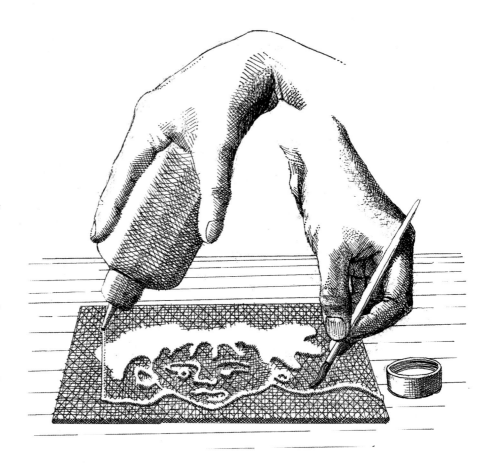

use a sponge or rag to dab ink on to the block's surface. Lay a clean sheet of paper onto the inked block and print by burnishing. Carefully peel up a corner, every now and then, to see how the print is progressing. When it is printed to your satisfaction, peel the print away from the block. The image will be a mirror-image of that on the block, but the glue marks make a positive image.

Note that PVA will swell and soften if it remains in contact with water for long periods so, after printing with water-based inks, when cleaning the block with water afterwards – do not let puddles collect on its surface, pat it dry with kitchen roll or rags.

Above *Untitled portrait, 187 x 204 mm, by Hester Pelly (art student). The glue block was inked using a pounce.*

Below *'Man and angel', 460 x 350 mm, by Jim Anderson, uses glue and collagraph techniques.*

The two blocks were inked with a roller and printed by spoon-burnishing.

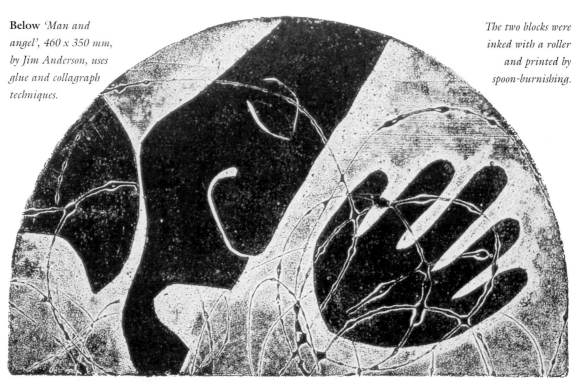

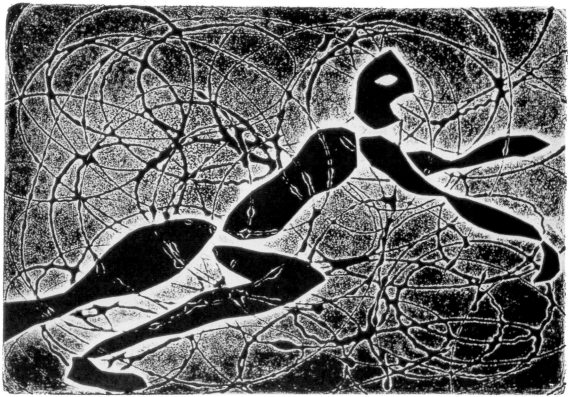

COLLAGE PRINTS

Collage offers another use for glue and card for the production of unusual prints, rich in texture and with strong sculptural qualities. Prints made by this method are known as *collagraphs*.

To make the plate, you can use materials such as corrugated cardboard, textured paper (for example, doilies), crumpled paper or tin-foil (though foil can be difficult to stick down), cloth, bits of netting or flat leaves. Details and textures can be added by gluing further materials to the surface, for instance, string, strands of glue, sand, sugar, coffee granules, dry tea leaves, dried rice, spaghetti, lentils or seeds. You can stick down anything that is more or less flat. Ensure that:

1 everything is well stuck down. Spread glue right up to the edges on the backs of everything to be glued (or apply glue to the collagraph's surface and drop, for instance, coffee granules, on to it). To avoid making a mess, spread out the objects on to newspaper before applying glue. The glue-stained newspaper can later be thrown away. Leave the collaged block under weights (such as several heavy books) overnight, so that it dries flat and its components are stuck down firmly.

2 fluffy textiles or sharp materials are not used as neither will print well. Materials such as mohair wool will deposit fluff when you ink the block and sharp materials – such as staples, wire or slivers of wood – may damage your roller (if inking by roller).

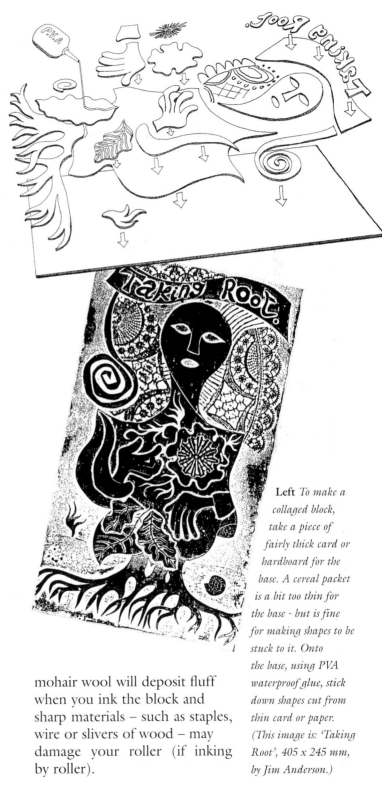

Left *To make a collaged block, take a piece of fairly thick card or hardboard for the base. A cereal packet is a bit too thin for the base - but is fine for making shapes to be stuck to it. Onto the base, using PVA waterproof glue, stick down shapes cut from thin card or paper. (This image is: 'Taking Root', 405 x 245 mm, by Jim Anderson.)*

63

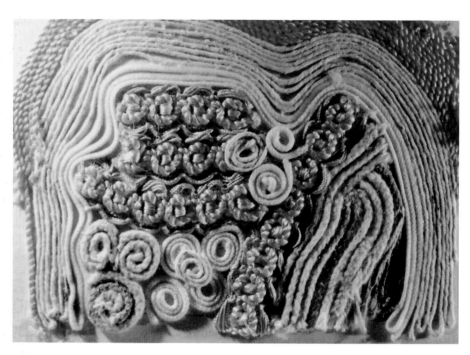

Right *Detail of a collagraph block (detail size: 125 x 170 mm) by Joan Vere. A talented seamstress, she made this, only her second collagraph, at an evening class. The composition, inspired by a photo of mushrooms growing among tree roots, is made from wools and rafia from her needlework basket. The block was sealed with shellac varnish prior to printing.*

3 the ingredients of your collaged block are of a relatively similar height as too much variation will create a difficult surface to print. If, for instance, a piece of net fabric is much shallower in height than your other selected materials, stick it to a spare piece of card or thick paper, to increase its height, before pasting it to the base.

Once the block is completely dry, paint over the whole collaged surface with a thin coat of liquid shellac varnish or use diluted water proof PVA glue (a mix of about 70% glue to 30% water) to seal the block, making it much more durable and less liable to go soggy if printed with water-based inks. (Note, however, that shellac varnish is the better choice of sealant because, if printing in warm conditions, there is a danger of PVA becoming tacky which could cause the printing paper to stick to it.) When the sealed block is dry, ink it with a roller, brush or pounce. If desired, you can apply different colours to different areas of your collaged block in order to make a multi-coloured print. Lay a sheet of paper over the block and print by burnishing.

Below *The collagraph was inked with a pounce and printed by foot pressure, onto cartridge paper.*

64

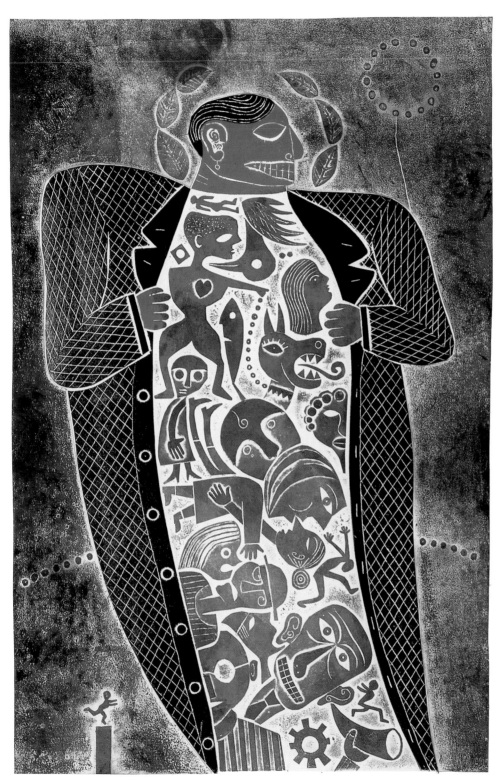

Left *'My name is Legion' or 'The Exhibitionist', 525 x 350 mm, collagraph printed in relief, by Jim Anderson. The collaged block was inked with a pounce for the coloured areas and a roller for the black parts. It was printed on smooth cartridge paper by spoon-burnishing.*

7 Woodcuts & linocuts

WOODCUTS

Woodblock prints are known to have existed at least since the T'ang period in northern China (627–649 AD) when they were used to broadcast Buddhist doctrines. The realisation spread swiftly through the Orient that illustration and text could be replicated easily and woodblock printing was well established in Europe by the 15th century when it primarily served the church, state and universities. Presses were gradually introduced in the West while, in the East, the tradition of hand-printed woodblocks continues to this day. Strictly speaking, the term *woodcuts* is applied to prints with this medium printed in the West, using oil-based ink and a press, whereas *woodblock prints* are printed by hand, in the East, using water-based inks. Increasingly, however, Western artists are using water-based inks and many employ hand-printing methods so these definitions are becoming blurred. Woodcut is an increasingly popular print medium. The grain on different woods produces varying and beautiful printed effects and these can be emphasised by scrubbing the block with a wire brush or steel wool prior to cutting. Chipboard has no grain and is difficult to cut but its textured surface can create an interesting pattern.

Wood is sawn in two ways: in

Above *'South-east from Charing Cross', 870 x 580 mm, by Saša Marinkov. Woodcut on Malaysian ply, inked with oil-based ink and printed by burnishing with a wooden spoon onto Shoin-bis paper.*

Side-grain/long-grain

End-grain

Above *'Combing the hair', 445 x 345 mm, by Goyo Hashiguchi (1880 - 1921).*
© The British Museum. Japanese woodblock print comprising several side-grain
blocks of mountain cherry wood inked with water-based colours and printed
with a baren, one after another, in perfect registration.

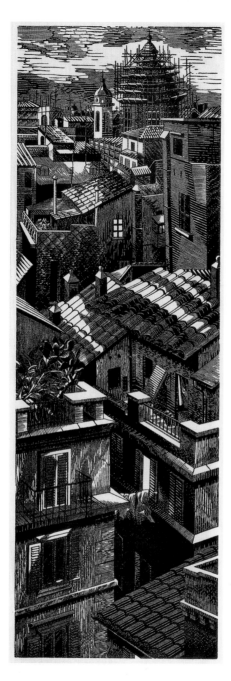

Right *'Roma',*
610 x 200 mm, by
Anne Desmet.
Linocut inked with
oil-based ink mixed
to a blue-black hue,
printed by burnishing
with a wooden spoon
onto Japanese Kozu
shi paper.

planks, along the grain (side-grain or long-grain) or across the trunk (end-grain). Woodcuts are made on side-grain wood while wood engravings (see Chapter 9) are usually made on end-grain which has a more uniform texture with no grain apparent in the printing, giving it a different character and making it more appropriate for finely-detailed work on an intimate scale. Woodblocks need not be regular in shape but do need to be relatively flat.

LINOCUTS

Linocuts are made from linoleum, a flooring material developed in the 1860s. Linoleum is made by laying a mixture of linseed oil, resin, powdered cork and pigments (to provide colour) on to a backing of woven jute (also called hessian or burlap). Linseed oil is pressed from flax and the origin of the word 'linoleum' comes from two Latin words 'linum' (flax) and 'oleum' (oil). Nowadays, as a flooring material, traditional linoleum has largely been superseded by vinyl equivalents which are often misleadingly called lino. Some of these vinyls make reasonably good lino substitutes for printmaking purposes though many have a strong surface texture or pattern which may dominate images cut and printed from them.

Linocutting has long been associated with printing in schools since Franz Čisek, an art teacher in turn-of-the-century Vienna, introduced it into his classes. His pupils' prints made a huge impression on all who

Left 'Angel',
*102 x 75 mm, by
Katy English (age 4).
Linocut inked with
water-based ink,
printed by burnishing
with a spoon onto
sugar paper.*

saw them and led to the swift, enthusiastic adoption of linocutting in schools and by professional artists. Linocutting was also much used by Russian artists, under the Soviet regime, for the production of political posters. Jewish artists used lino flooring to make prints to satirize the Nazi regime, when all other printmaking materials had been confiscated from them. Enthusiasm for linocutting has not dwindled.

Linoleum is a versatile and relatively cheap material. It has no grain so marks cut into it have a crisp, distinctive character. It can be used

equally effectively to make black and white or multi-coloured images. The lino block is quite durable and, if treated carefully, will withstand repeated printings.

Tools and equipment

Wood and lino blocks
Many different kinds of woods can be used – from an old door or plank found in a skip, to a block of pine or plywood, to a small, perfectly seasoned piece of side-grain cherrywood

purchased from a specialist print-making supplier. Lino is readily available in art materials' shops and is usually either peanut-butter or mud-grey in colour. It comes in varying sizes – from tiny rectangles to large sheets or rolls.

Wood and linocutting tools
To cut wood and lino you need special tools. Cutters with detachable blades are the most inexpensive and readily available from art and craft shops. They are adequate for children or beginners; their drawbacks are that they are difficult, if not impossible, to sharpen and often have cumbersome handles. They are only suitable for linocutting and strictly for short-term use as they blunt quickly. Cutters with fixed blades set in tubular or

Below *A U-gouge and a V-gouge tool, each set in a mushroom-handle; three Japanese cutters; and a fabric roll for the storage and protection of tools.*

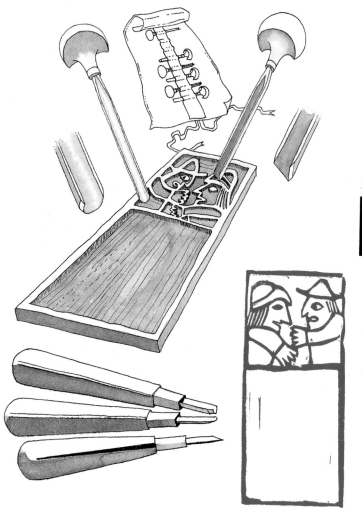

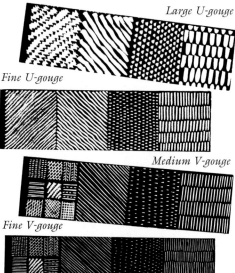

Large U-gouge

Fine U-gouge

Medium V-gouge

Fine V-gouge

Above *The U-gouge makes relatively broad lines or rounded marks and is useful for clearing away large areas of lino. The V-gouge makes finer lines or triangular marks. Both come in a range of sizes.*

WOODCUT SAMPLES

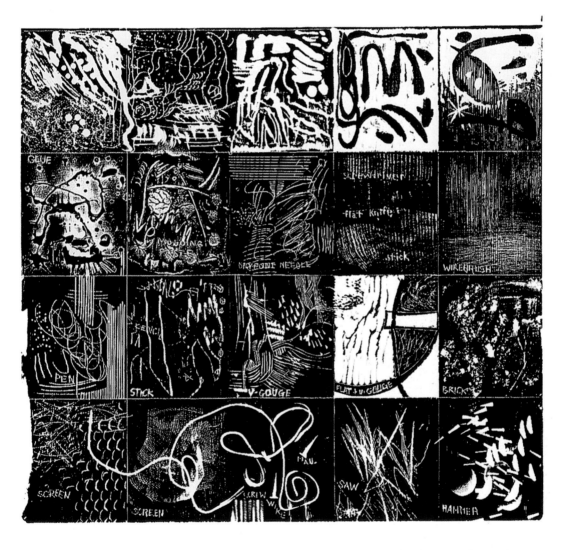

Above *'Woodcut Samples', 538 x 425 mm, by Susan Conti and Anne Gilman. The top squares show cutting with conventional tools. The next row has textures made with glue, plaster, etching needle, screwdriver, knife, stick and wirebrush. The third row shows ballpoint pen, pencil, stick and brick dents and V and U gouged marks. The bottom row has mesh netting, a nail, wire, screws, a saw and hammer-marks hammered into the wood.*

71

mushroom-shaped handles are more expensive but are much more hardwearing, easier to manipulate and can be sharpened more easily. Good quality Japanese-style cutters with adjustable blades are a useful alternative.

Roller

A printing roller is desirable for inking woodcuts and linocuts. Otherwise, use a brush or pounce.

Ink

You can use oil-based or water-based printing inks or gouache to print woodcuts and linocuts.

Paper

Lino and woodblocks can be successfully printed onto a wide range of papers including all those listed in Chapter 1.

Preparation of lino

When you buy lino, you will notice that its surface texture is slightly rough. If you were to print it in this state you would find that uncut areas would print with a granular texture rather than as a solid area of colour. Before you start drawing on and cutting the lino, lightly rub down its surface with fine wet-and-dry sandpaper. This is a quick and easy preparatory stage and will make a great difference to the quality of your prints. Place the unsanded block on to old newspapers (to soak up the mess) and add a few drops of water to the lino's surface. Start rubbing with the sandpaper,

through the water, adding more water, as necessary. You don't need to rub hard. Try sanding just one corner first, then compare the difference. Even quite large blocks only take a few minutes to sand. When finished, wash the watery residue off the surface with clean water and rags or paper towel. Try not to get the hessian backing of the lino too wet. The block will take about five minutes to dry.

You might find it helpful to mount a large lino block on to hardboard, of the same size as the block, glueing it down with PVA glue. This isn't essential but will provide a strong rigid surface on which to cut.

If the lino is too hard to cut easily, warm it on a radiator, with a hair-dryer, or lay a hot-water-bottle on it for a few minutes. Repeat as necessary when the lino cools if cutting becomes difficult.

Preparatory drawing and transferring drawing to block

It is easy to draw directly on to wood or lino with a soft pencil. Reinforce the drawing with a dark marker pen or felt-tip – so you don't smudge it while you are cutting. Alternatively, work out the drawing on paper beforehand, then transfer it to the block.

1 Trace it on to tracing paper using a soft pencil. Place the tracing face-down on to the block and tape it to the block's

edges. Draw over the back of the traced lines using a hard pencil or ballpoint pen, pressing firmly. Reinforce the transferred lines with a marker pen. The design will be a mirror-image of your drawing but the printed image will be the right way around.

2 More simply, place a sheet of carbon paper carbon-side-down on to the block. Place your original drawing face-up on top and tape its edges to the block. Draw, with a hard pencil, over the lines of your original drawing to transfer it. The carbon lines are sometimes so strong that they don't need reinforcement. The transferred

image will be the same way around as your drawing so note that, when cut and printed, the print will be a mirror-image of the drawing. For images involving letters or numbers use tracing paper.

Drawing to scale

It helps to make your drawing the same size as your block – for ease of transferring it. Otherwise:

1 Make a print of just a detail of your original (if the drawing is too large) – which you can transfer either with carbon or tracing paper.

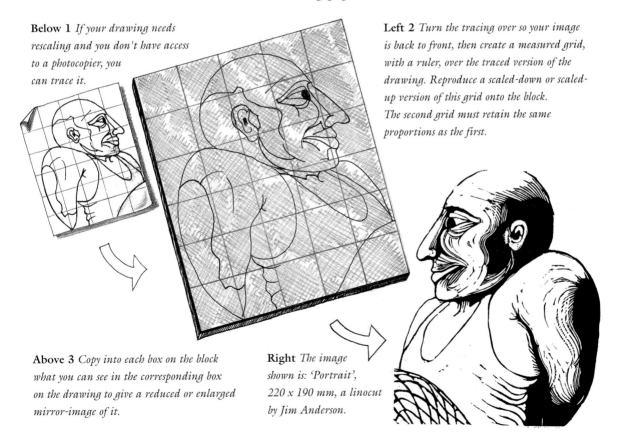

Below 1 *If your drawing needs rescaling and you don't have access to a photocopier, you can trace it.*

Left 2 *Turn the tracing over so your image is back to front, then create a measured grid, with a ruler, over the traced version of the drawing. Reproduce a scaled-down or scaled-up version of this grid onto the block. The second grid must retain the same proportions as the first.*

Above 3 *Copy into each box on the block what you can see in the corresponding box on the drawing to give a reduced or enlarged mirror-image of it.*

Right *The image shown is: 'Portrait', 220 x 190 mm, a linocut by Jim Anderson.*

73

2 Cut your block down to fit a small drawing.

3 If the drawing is fairly simple, copy it directly onto the block, reduced or enlarged as required.

4 Rescale it on a photocopier, then trace or carbon copy the photocopy onto the block.

Mark-making

Cutting slices from a block
Draw a straight pencil line where you wish to make your cut. Then, with a craft knife and metal ruler, score along the line. Bend the lino along the scored line; it will split easily and its hessian backing can be readily cut with knife or scissors. To cut a piece from a wood block you need either a handsaw or electric jigsaw.

Cutting a design on to the block
Remember that everything you cut will make the white areas of the print (assuming you are printing on white paper) as you apply ink to the block's uncut surface. So, to cut a black line on a white background, cut away all the surrounding area of the block on either side of an uncut ridge. That ridge will form the black line when printed. Remember that the finished print will be a mirror-image of what you cut.

Hold the handle of the gouge in the palm of your hand, with blade protruding between thumb and forefinger, then push the cutting edge into the lino. Lower your cutting hand (keeping the blade inserted in the block) so that hand and tool handle are as close to the block's surface as possible; now push the tool along the block to make a cut. *To avoid injury remember, at all times, to cut away from your body and keep your non-cutting hand well clear of the path of the blade.*

Etching lino

As well as taking crisp cut lines, lino can be etched with caustic soda solution to provide areas of granular texture which can be effectively used, in conjunction with the cut marks, to provide a contrast of surface tone and a different quality of painterly mark. *Caustic soda is a dangerous, corrosive alkali and should be stored and handled with extreme care.* It is sold in crystals at hardware shops.

Place three or four tablespoonfuls of water into a glass jar. Slowly add caustic soda crystals, a spoonful at a time (using a plastic spoon as caustic soda corrodes metals), allowing the crystals to dissolve before adding more. Stir with a wooden stick. Continue until a saturated solution is attained – that is, when no more crystals will dissolve. NB *Never* add water to caustic soda crystals – *always* add caustic soda to water. Also, *wear protective rubber gloves and goggles, as caustic soda can cause serious burns;* work near a source of water so that if any splash of etch contacts your skin you can

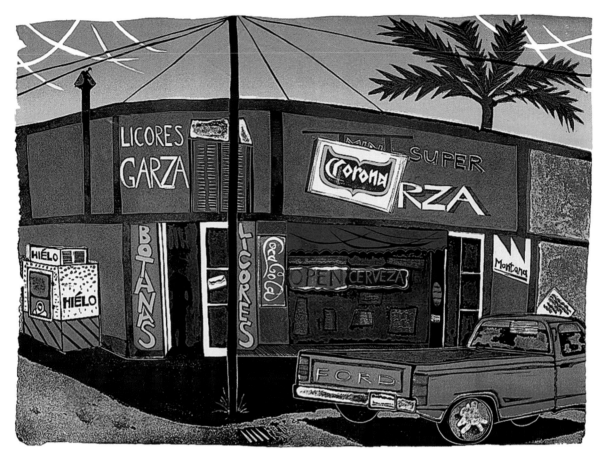

wash it off immediately; and keep your face clear of the fumes. During the mixing, the etch will become very hot so leave it to cool before use. Rub the lino clean with methylated spirits on a rag, prior to applying etch, to remove any greasy areas which would repel the solution. Add a few drops of methylated spirit to the etch to make it flow more readily and paint or drip it, with a nylon paintbrush, on to the surface of the lino. (Natural hair brushes are not suitable as the etch destroys the bristles.)

For greater control when applying the etch, add wallpaper paste to it, to thicken it, or mix the solution with PVA before painting it onto the lino's surface. The wallpaper paste can later be washed off with water along with the etch; or the PVA can be peeled off the block (after the etch has been washed off) before printing. To make a much stiffer, less free-flowing solution, which can be applied to the block with a large stiff brush, mix one part caustic soda solution with two parts acrylic medium. Use immediately as the acrylic medium quickly dries out.

Leave to etch for between about one and six hours. Soft lino etches faster than older, harder lino; etching in warmer temperatures works

Above *'Licores Garza', 380 x 520 mm, by Fiona Hamley. Reduction linocut combining caustic soda etched textures with marks cut with U and V gouges; printed on Fabriano 5 paper in several colours including a blend. This was printed on a press but, with careful registration, it could be printed by hand.*

75

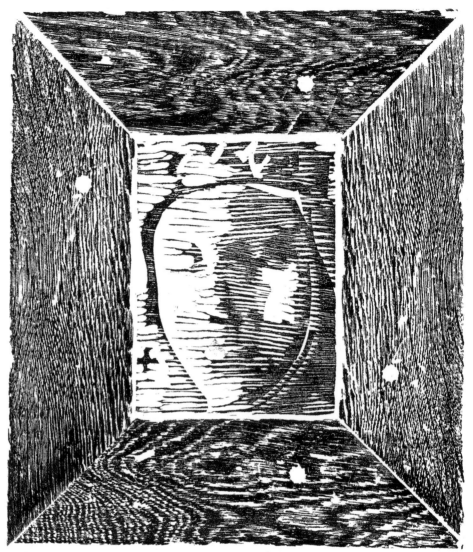

Right *'Aliénor d'Aquitaine', 330 x 290 mm, woodcut printed on BFK Rives paper by Jean Lodge: 'some very weathered oak planks that I found, on which I enjoyed the woodgrain, came to mind. These pieces of timber are not at all flat, quite apart from being wedge-shaped in section. Several are over a metre long. I decided to try printing a sort of frame to go around a small woodblock (portrait). I printed the frame using stencils (of greaseproof paper) so as not to have to cut the timber and burnished the back of the paper with a wooden spoon. I do not believe it would be possible to make this image in a press.'*

faster than in the cold when the etch sometimes doesn't work; the longer the etch stays on the lino, the deeper it will bite – these varying bites will print with different (unpredictable) intensities. To clean the block of caustic soda and of etched particles of lino, scrub it with an old, long-handled, washing-up brush under a stream of cold water. Try not to get the lino's hessian backing too wet.

Etch can be applied all over the surface of the block or painted onto localised areas. Alternatively, areas which you do not want etched can be masked out by painting molten wax or applying very greasy oil crayons on to the block before applying etch over its whole surface. To remove the dry wax prior to printing, soften it with a hairdryer and scrape off with a palette knife.

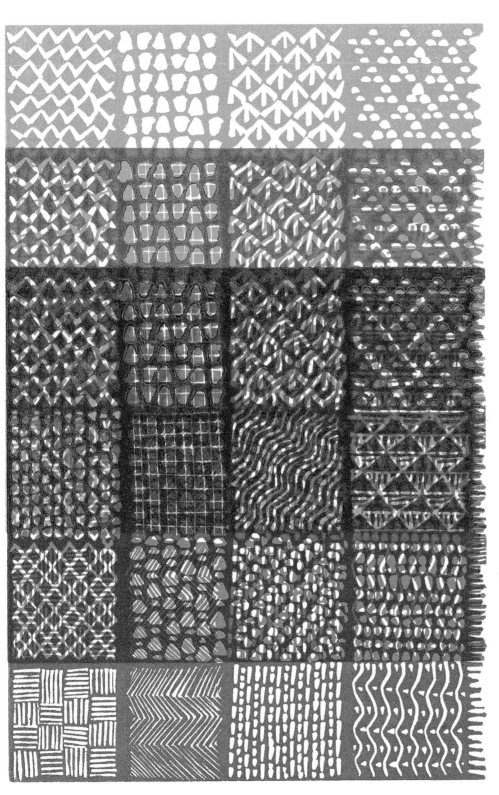

Left *A lino block inked first in mustard-yellow, then re-inked in red and printed on top of the first printing but shifted down slightly (as illustrated), then re-inked in a third colour (blue) and printed over the first printings, shifted down further, as shown. This is an easy way of making a fairly simply cut pattern achieve a rich complexity.*

Above *A simple registration board with the block in position.*

Above *The paper is slotted in place, ready for printing.*

Right *'Parzival's Castle', 300 x 227 mm, three-colour linocut printed by roller-pressure, using a clean, hard roller, rolled over the back of the mauve sugar paper. The artist was a nine year old pupil from Caersws School, Powys, Wales. This was her first linocut and took about four hours to cut and print.*

Printing in one colour

Roll out some printing ink on to a slab (or, if you favour the Japanese method, mix watercolour or gouache in a dish). When it is smoothly rolled (or mixed) use the roller to apply ink, evenly, on to the block's surface (or apply ink with a Japanese inking brush); it is sufficiently inked when you can hold it to the light and see that it glistens evenly, all over. If you see any dull, matt areas you need either to apply more ink or to roll out, more evenly, the ink already on the block. When it is fully inked, place it on a clean surface, lay the printing paper gently on to it and spoon-burnish or baren-burnish the paper. If the block is very large it can be printed by foot pressure.

Printing many colours from a single block

You can print an image of many colours from just one piece of wood or lino. A versatile way of achieving this is called the reduction method because, between each printing in a new colour, you continue cutting the block – thereby gradually reducing its uncut surface.

To make a reduction print:

1 Transfer the drawing on to the block.

2 If printing with water-based inks, reinforce the image on the block with a spirit-based marker pen. This will prevent the drawing from being washed off by successive printings followed

Left *Printing stages of 'Taormina', 95 x 56 mm, by Anne Desmet; a three-colour linocut printed in water-based inks on Zerkall paper. The block was first printed in yellow. It was then cleaned, cut further, re-inked and printed in brown, overprinting the yellow. The block was cleaned again, cut further still, re-inked and printed in blue over the previous two colours.*

Left *'Parzival's Castle' showing only the last stage of the reduction cut, printed in blue water-based ink on pink sugar paper. These two prints were made during a children's workshop at Oriel 31, Newtown, Powys, Wales.*

by cleaning with water. If you intend to print with oil-based inks, reinforce the drawing with a water-soluble ink such as Indian ink.

3 Register the block and paper on a board so that each printing falls in the right place. Glue a few strips of cardboard onto a flat piece of hardboard to provide a right-angled corner and a straight edge, against which the block can be slotted into place. Glue equivalent markers to the board to register the position of the paper.

4 Cut away all areas of the block which you wish to appear white in the print (assuming you are using white paper). Ink and print the block. You may get more successful results if you choose a light colour first, then successively darker hues for each overprinting.

5 Apply ink as thinly and evenly as possible as, if it is too thick, it will take a long time to dry and when the prints are overprinted with successive layers of ink, that first layer may pull right off the paper and stick to the fresh ink on the block. Don't worry if your first few printings are patchy in parts as they will even out as you print successive layers.

6 With this method, it is not possible at a later stage to reprint what you had at the beginning.

So, to ensure that you end up with a reasonable number of successful completed prints, it is worthwhile printing many copies of the first printing to allow a margin of error for mistakes with colour of registration at later stages.

7 Once you have finished printing, clean the ink off the block. Use water to remove water-based ink; use vegetable oil (followed by washing-up liquid and water) or a tiny amount of white spirit to clean up oil-based ink.

8 Cut away more of the block, ink in a new colour and overprint your first prints. Clean the block between each stage of printing. Continue cutting and printing until the print is finished.

Right *'Dispute',
750 x 490 mm, by
Jim Anderson. A
reduction linocut
with seven stages of
cutting and a stencil
through which the
sky was printed.
It was printed in oil-
based inks on to
a thin, smooth,
Japanese paper by
spoon-burnishing.*

Colour blending

Another way of gaining a multi-coloured print from a single block is to use colour blending in which two (or more) colours are blended on the inking slab, then carefully rolled onto the block. Colour blending can also be used to print blocks other than wood or lino – for instance potatoes, card, collage, and glue blocks.

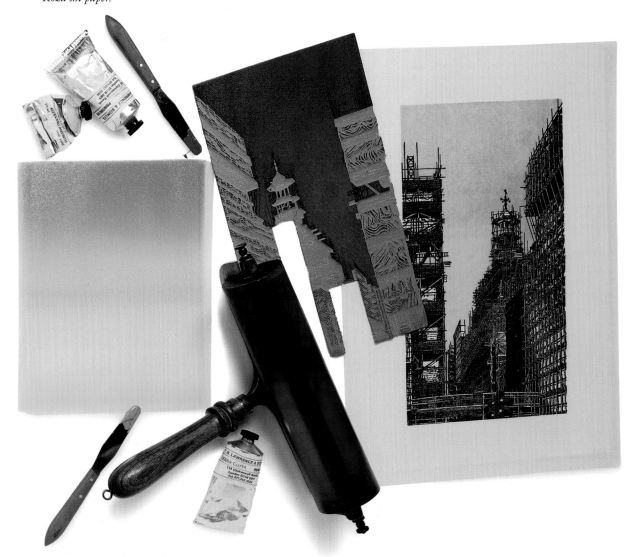

Above *To make a blend, take a roller as wide or wider than your block. Place on the slab two blobs of ink, each of a different hue (and use extender, if desired, to produce translucent effects), on either side of the roller's width. With two palette knives smear a line of ink inwards from each blob until the colours are just touching. Roll the ink back and forth until it is evenly rolled. Now ink the block. On both slab and block, be sure to roll in only one direction to maintain the blend.*

Above *The first stage of a complex reduction linocut by Dale Devereux Barker. The block was inked with a three-colour blend of cream, yellow and brown.*

Above *After the first printing, the block was cleaned and further areas of lino were cut away. It was re-inked in blue and printed over the first blended printing.*

Above *After the second printing, the block was cleaned and further areas of lino were cut. It was re-inked in a pink and cream blend and printed over the first two printings.*

Above *After the third printing, the block was cleaned and more areas of lino were cut away. It was re-inked in a green and yellow blend and printed over the first three printings.*

Above *'The next age-group', 244 x 244 mm, by Dale Devereux Barker, underwent two final stages of cutting and printing (in black, then red). It was printed in oil-based inks.*

Printing many colours from many blocks

Multi-coloured prints can also be created by cutting several separate pieces of lino or wood, each of which can be inked and printed in a different colour, to make a single image. An advantage of this technique over the reduction method is that you can print as many copies of your finished print as you like – as you do not re-cut blocks between printings. A disadvantage is that it takes longer to plan and cut each block whereas the reduction method can yield a multi-coloured print more swiftly and with less forward planning.

Far left *The yellow component of a three-colour, three-block woodcut (this block was used as the key block).*

Left *The red component of the print.*

Below left *The blue component. All three blocks were of thin plywood.*

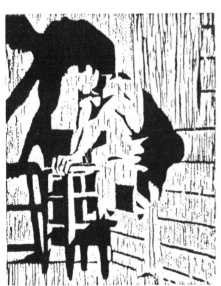

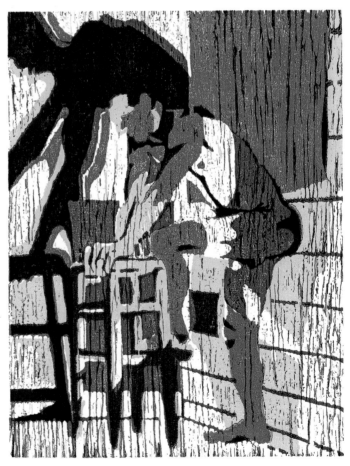

Right *The three blocks were inked, registered and printed, starting with the yellow block and ending with the blue one. This liferoom study, 288 x 229 mm, was a student work by Anne Desmet.*

85

To make a multi-coloured print using several blocks:

1 Make a drawing in colour. Scale it to fit a block. Try to use fairly simple outlines with shading to indicate different areas of colour.

2 Take a separate block for each colour; all the blocks should be of exactly the same dimensions. If you have coloured your drawing in, for instance, red, yellow and blue – you will need three blocks for the print. Where colours overlap, you may find new colours are created without the need for an extra block. For instance – red and blue make purple; yellow and blue create green; red and yellow create orange; red, blue and yellow create brown or black. So, for an image involving three blocks cut, inked and printed in just three colours, you could make a print in seven colours. If you cut away large portions of the blocks, when you ink them, the roller may deposit ink along the ridges of the cuts and these will print as faint lines and marks. This often adds a welcome texture. (See previous page for an illustrated step-by-step example of a three-block print.)

3 Transfer the drawing onto each block and cut each one leaving uncut, in each case, only areas which you intend to print. Ink, register and print the blocks as described for reduction printing.

4 Print all the copies you want in the first colour before moving on to the next, rather than having slabs inked in different colours simultaneously, some of which may be drying out while you're printing with others.

An easy method of transferring an image onto several blocks is by offset printing. This is a very useful technique, particularly if you don't want to pre-plan the finished image to the degree described above. Offset printing allows you to cut one block which can then be used as a template for cutting the others.

To offset a print:

1 Cut one block which, when printed, will comprise one coloured area of your finished print. Incorporate into this first block a large part of your preparatory drawing, so that it will provide a good, clear template (known as the key block) from which to decide areas to be cut on successive blocks.

2 Print this block in the usual way on to your choice of paper but, in addition, print one copy on to a fairly shiny, non-absorbent paper: tracing paper works well for oil-based inks but will cockle if used with water-based inks; use drafting film (available from suppliers of graphic art materials) for printing water-based inks.

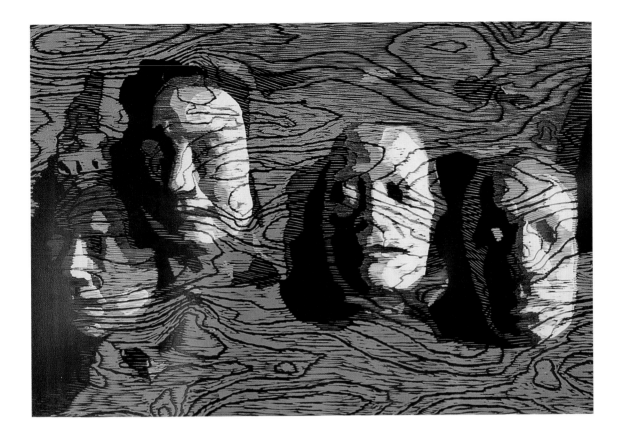

3 While the ink on it is still wet, place the tracing paper, printed side down, on to the second block (which should be exactly the same size as the first). Make sure that the print is positioned in exactly the right place. If you have printed on tracing paper, this is helpful as the ink shows through it, enabling you to see clearly where to position the print on to the new block.

4 Tape the tracing paper on to the new block to hold it in position for offset printing.

5 Hand-burnish the wet print on to the new block.

6 Peel off the tracing paper to reveal the print from the first block neatly offset on to the second. The offset print is a mirror-image of the print on the paper and so is the right way around to act as a template for cutting the block, once the ink has dried.

7 You can offset print the first block on to as many other blocks as you need for your multi-colour print; each offset print must be made from a freshly printed impression on tracing paper or drafting film, depending on what type of ink you are using.

Above *'Masks of the Immigrants', 650 x 1000 mm, by Jean Lodge. Three-colour woodcut printed by spoon-burnishing. A separate block was cut for each colour.*

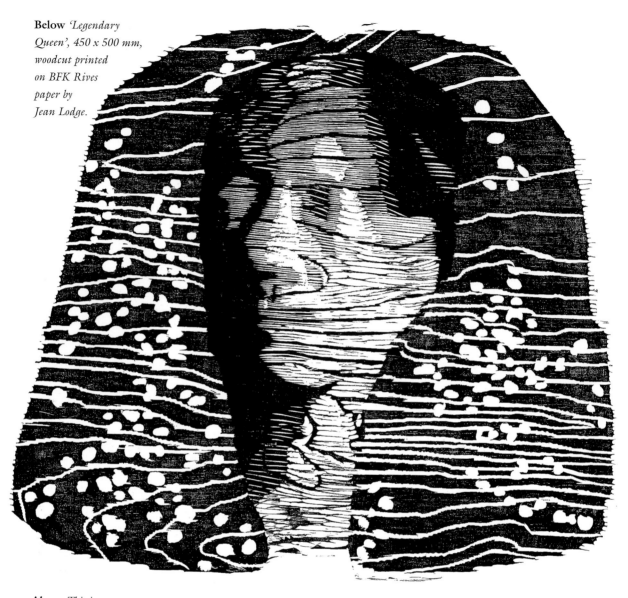

Below *'Legendary Queen', 450 x 500 mm, woodcut printed on BFK Rives paper by Jean Lodge.*

Above This image combines a portrait in 'Masks of the Immigrants' (see previous page) with a totally different woodblock to create a new image altogether. It was printed by burnishing with a wooden spoon.

Jigsaw blocks

A simpler way of producing multi-coloured prints is by the jigsaw method. This is suitable for designs involving clearly defined areas of colour – where no colours overlap. It gets its name because the different elements of the design are cut out and reassembled like a jigsaw.

To make a jigsaw block:

1 Draw (or trace) a design with strong outline shapes on to a block. Decide which areas are to be printed in different colours (these should be fairly bold, simple shapes or they will be difficult to cut) and cut out each shape completely, from the

block, using a craft knife for lino or an electric jigsaw for wood. *Be careful not to cut yourself.*

2 You can, if desired, cut textures or delineate areas of the drawing on your jigsaw pieces.

3 When cutting is complete, take each fragment and ink it up in a different colour. You will need to work quickly, so that the first block doesn't dry before you've inked the last.

4 When all the pieces are inked, reassemble them to form the complete picture. It may help to make a cardboard frame, to hold the pieces in place as you print.

5 Print by burnishing.

Tools: care of/sharpening of wood and linocutting tools

It is important to keep tools sharp. A blunt tool is hard to use and may slip on the block while you are cutting – which could harm both you and the block. When not in use, keep tools in a soft fabric tool roll to protect the blades. Don't store them with their blades rubbing against one another or against any other metal

Below *'Not Predatory', 560 x 760 mm, jigsaw woodcut by Sandy Sykes. The animal was cut out from the block using a mechanical jigsaw on a workbench. The imagery was cut with woodcutting gouges and mechanical tools. Printing, onto Khadi handmade Indian paper, was done by burnishing with a baren, a wooden spoon and a glass pestle.*

90

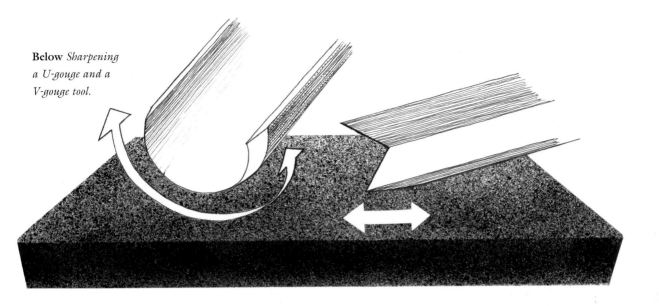

Below *Sharpening a U-gouge and a V-gouge tool.*

surface as this will quickly blunt them. Lightly oil them, from time to time, to prevent rusting. The soft metal of cheaper tools is difficult to sharpen in comparison with more expensive tools (which have blades made of stronger steel). It is not difficult to sharpen tools, but requires patience and practice. Alternatively, suppliers of specialist tools often offer a relatively cheap sharpening service.

To sharpen tools you need a Carborundum or India Stone (available from retailers of print-making materials). Add to its surface a few drops of thin oil (of the sort used for oiling bicycles, etc.).

The two outer faces of the V-tool's blade need to be sharpened separately by holding the tool at a slight angle (approximately 20°) to the oiled sharpening stone. Push the tool gently backwards and forwards. When one side is sharpened, turn it over to sharpen the other 'arm' of the 'V'. The curved cutting edge of the U-tool needs to be sharpened

by, again, holding it at the same angle to the stone but, this time, rotate the tool gently from side to side. To obtain a finer edge, after general sharpening, use smoother stones such as Arkansas or Washita.

When you have sharpened each tool, rub the inside of the blade very lightly across a slim, slightly rounded slipstone for U gouges or a triangular-in-section slipstone for V gouges, or across a piece of fine polishing paper (wet and dry sand-paper of the smoothest grade – 400 grit or higher – available in DIY/hardware stores and in suppliers of jewellers' materials). Pull the stone or polishing paper along the inside of the blade, moving from handle end to cutting edge in a swift clean movement. One or two light strokes should be enough to remove any 'burr' of metal which may still be clinging to the tool's cutting edge. Test its sharpness by cutting into a spare wood or lino block. If still blunt, repeat the sharpening process until it cuts cleanly.

Far left '*Big Bad Wolf', 1420 x 1070 mm, by Sandy Sykes. Jigsaw woodcut on an old, weathered billboard, cut with a mixture of woodcutting, engraving and carving tools, a mallet and an electric glass-engraving tool. Jigsaw blocks were printed in semi-transparent ink layers on to Indian paper which had already been collaged with tissue-thin papers printed by the artist. Printing was done by baren and spoon-burnishing, applying varying degrees of pressure to achieve different densities of colour.*

91

8 Stenocuts

Below *To transfer a photocopy, place it face down on to the block. Rub all over the back of the copy, lightly, with a small amount of oil of wintergreen* on a rag or paper towel; (*a methyl salicytate muscle rub available from pharmacists. This fluid must be handled with care; it has a strong odour, so ensure your workroom is well-ventilated. **Also, beware: it smells edible but can be fatal if consumed**). Peel off the oil-saturated copy (which should be placed outside to dry or carefully wrapped in plastic and disposed of). The transferred image will need no blotting and will be dry in about five minutes.*

Stenocut is a new and versatile print process devised and developed only within the last decade by American artist Sue Anne Bottomley. It is a relief printing process with similarities to linocutting. Instead of linoleum, however, the printing block is a rubbery material sold for use by stonemasons and signmakers; it is readily available from monument and sign companies at affordable prices. Its commercial product name is Anchor no. 111 sandblast stencil. Some printmakers use Anchor no. 125 which has a more sticky backing. (These are the names to ask for when buying – not

the coined word *stenocut*.) This soft grey-white rubber comes from the factory in rolls, 760 mm (30") wide by nearly 10 m (32.8') long. Retail outlets usually offer smaller pieces for purchase as well. It cuts extremely easily with linocutting tools, prints crisply and is durable enough to withstand repeated printing. As the material is both soft and thin, it can be readily cut with scissors or craft knife to create jigsaw blocks. Bottomley chose the name *stenocut* both for its allusion to the word 'stencil' and because the Greek root *steno* means thin or narrow. The thinness of the printing block is one of its significant and useful features.

The material comes with a sticky coating on the back, to which is attached a plastic film backing. Peel off this film and press the block, sticky side down, on to a sheet of mount card to give the plate some

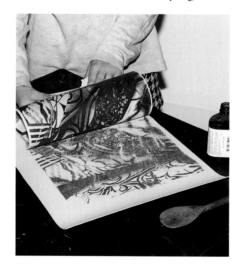

Right *'Leaving Home in a Paper Airplane', 390 x 390 mm, by Sue Anne Bottomley. Jigsaw-cut stenocut composed by photocopier transfer then cut like a lino block. The wet ink was smudged, after printing, to soften some hard edges.*

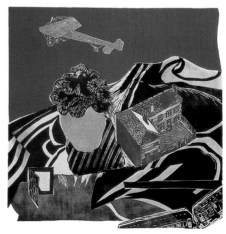

rigidity, for ease of handling and carving. Choose very smooth card to ensure its complete contact with the sticky surface of the block. Transferring designs on to the stenocut material is easy as soft pencil drawings and linear newspaper images (on issues still fresh enough to smudge) both transfer by straight-forward burnishing. You can also transfer copier images onto it.

As well as offering a means of utilizing commercial imagery, photocopy transfer is a useful way of incorporating your own photographs or sketches in a stenocut and also gives you options of rescaling or reversing your image, prior to its transfer to the stenocut block.

Another method unique to stenocut is embedding. Peel off the plastic backing and lay the block sticky side up. Now place on to the sticky surface thin, strong, relatively flat items such as string, cut shapes of mount board and – for lovely thin lines, pine needles. Then press a smooth piece of mount board on to the sticky side of the embellished block. Flip the block over (stenocut side up) and press firmly around it with your thumbs to seal the sand-wiched shapes. Trim the edges of the block before printing.

Ink the block as for a linocut, using water-based inks, and print by spoon-burnishing. While Bottomley highly recommends the use of water-based inks, if you want to print with oil-based inks, once the plate is carved, you should coat its surface with two coats of acrylic medium (used for acrylic painting) letting each coat dry overnight.

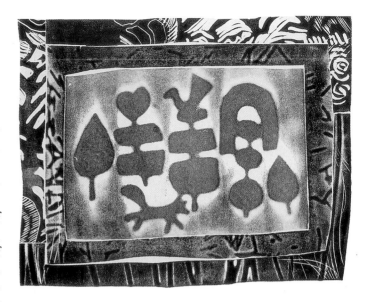

This is essential because oil-based inks will dissolve the surface of an unprotected stenocut block. Additional coatings may be necessary if the block and printing paper begin to stick together. When cleaning off ink, it is important not to use too much water as the card mount will absorb liquid and separate from the block. Simply place the block on newspaper, on a flat table, then wipe clean its surface only.

To make multi-colour stenocuts, blocks can be prepared, cut and printed by the reduction method, multiple block method and jigsaw method (all described in Chapter 7). When using water-based inks which tend to dry quickly, note that not all the pieces of a jigsaw block need to be inked or printed at the same time – provided that you make a registration template (as described in Chapter 5) for their correct positioning. Embedded blocks can yield two-colour prints if both levels of the plate are inked.

Above 'Topiary Garden', 210 x 260 mm, by Sue Anne Bottomley. Stenocut printed with water-based inks. The border was created with both carving and embedding techniques, then cut into jigsaw pieces to fit around the central image, the elements of which were all made from embedded pieces of thin mount board sandwiched between the printing surface and the backing board.

9 Wood engraving

Below *The image on the blocks was traced from a pencil and watercolour sketch before being engraved with six tools. The blocks, which have been repeatedly printed and cleaned with white spirit, have had talcum powder rubbed into the cuts so that the image shows clearly.*

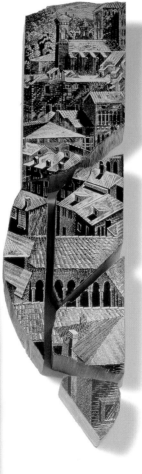

Wood engravings are usually made on end-grain wood. End-grain blocks are usually small by comparison to wood cut along the grain (side-grain). As the grain runs at right angles to the cut, it has little or no influence on the cutting which gives it a very different character to the woodcut. Engraving on close-grained wood with a fine, dense texture permits extremely detailed work – a predominant characteristic of this process. The wood needs to be seasoned for several years and the surface to be engraved should be planed and sanded to a completely smooth finish (like glass).

Engraving blocks can be purchased, ready to use, from specialist suppliers. Standard sizes vary from 50 x 50 mm (2 x 2") to about 250 x 200 mm (10 x 8") but larger blocks can be made to order. Large blocks are made by carefully joining a collection of smaller ones since the girth of the relevant trees does not allow for particularly large single pieces. Sadly, blocks even as small as 50 x 50 mm (2 x 2") can be surprisingly expensive as their seasoning and preparation are specialist skills. It is possible to buy, more cheaply, bags of engraving blocks in assorted shapes and wood varieties. These bags are sold by weight and their quality is variable. Their irregular shapes can lend character and inspiration to a composition. They are strongly recommended for a newcomer to engraving as well as for professional practitioners who are either working to a tight budget or who find their shapes inspiring.

The best wood (both for its durability and uniform consistency) is boxwood, but lemon is a similar and cheaper substitute. Other woods

including pear, cherry, holly and maple can be used but are variable in quality and are sometimes too soft or too crumbly to allow for engraving the finest lines achievable with harder woods. A suitable wood needs to be both very hard, so its surface does not crumble as more and more minute marks are incised upon it, and 'soft' to engrave. A good piece of wood should cut cleanly and easily, tools cutting through it with no hindrances (such as knots or variable patches of hardness or softness within a poor-quality block).

End-grain wood had long been used to carve hardwearing blocks for textile printing, but its use as an artists' medium was not established until the late 18th century when Thomas Bewick (1754–1828), in the UK, developed it for illustrating books because it would print many more impressions, before wearing down, than the traditional woodcut. It also took much finer cutting than side-grain wood. The technique burgeoned to become the prime means of production for both black and white and three-colour illustrations in books and periodicals until the advent of photography, in the late 19th century, heralded its decline. The majority of engravings were cut by artisans with no great artistic talent but with great technical virtuosity. Wood engraving requires both time and patience so, to produce large images very swiftly (to illustrate news reports for example), a master engraver would draw the design on to a large block which would then

Left *'Bergamo (fragments)', 285 x 82 mm, by Anne Desmet. Five engraved woodblocks printed by burnishing with a teaspoon onto China White laid paper. After printing, the artist carefully tore around each impression - allowing a small paper margin all around each imprint. The image was then reassembled by collaging its torn-edged elements on to a beige Japanese paper, the intention being to suggest remnants of a damaged fresco.*

Right *An increasing range of polymer plastic and synthetic resin wood-substitutes are available which feel similar to wood in the cutting but are available at much cheaper prices for large blocks. 'Rouen Palm', 210 x 116 mm, by Edwina Ellis, is an engraving cut on three blocks of 'delrin' - an acetyl-resin substitute for wood. Delrin can be cut with the full range of wood engraving tools whereas many other manufactured alternatives to wood respond best to cutting with gravers and less well to scorper-cutting.*

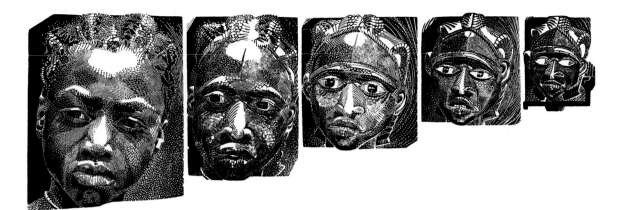

be divided into pieces, each of which would be engraved separately by one of a team of engravers – the juniors working on the easier areas of sky and so on while those with more experience tackled the more difficult figures, architecture, etc. Each would engrave not quite to the edge of his block so that when all the blocks were reassembled, the master engraver would finish these edges to link each block with seamless cutting. In the 1920s and 1930s, the revival of interest in fine book production in the UK also heralded renewed enthusiasm for wood engraving and, from this period, it has been used by artists in the spheres of illustration and design but also as a fine art medium, for the production of independent prints of immense detail and intensity.

Tools

Lino and woodcutting tools are not suitable for cutting end-grain wood. You need a range of specific tools (only available from specialist printmaking suppliers and a relatively expensive purchase). At first sight, having tempered steel blades set in mushroom-shaped, turned, wood handles, these look similar to good linocutting tools. On closer inspection, they are quite different. You can achieve excellent results with just two tools: a medium (or large) scorper (either square or round-ended) and a medium (or fine) spitsticker. The other tools and the range of fine, medium and large blades available in each tool type are all immensely useful for achieving ever-greater degrees of sophistication in the marks you engrave, but it is not worth buying more than two tools initially. Longer or shorter-length tools can be bought to suit the size of your hand: the blade should project just beyond the length of your index finger when the wooden handle is held cupped in the palm of your hand. A tool of the right length is much easier to manipulate than one which is too long or too short. If you look after your tools, although initially they may seem costly, they should last a lifetime.

Above 'Tompieme's Daughter', 85 x 240 mm, by Anne Desmet. Wood engraving on five blocks of assorted wood types, printed on a cream Japanese paper with a strong texture of silk fibres. One spitsticker and two scorpers were used to create the full range of tones in the left-hand portrait. The four smaller faces were engraved with these same three tools plus a multiple tool with three teeth.

97

Lozenge and *square gravers* were designed for making straight lines (the tool's sharp, straight back slots into the channel you are engraving and so directs it forward in a straight line). This sharp back can bruise the block's uncut surface (but its effect can be countered by slipping a thin piece of card behind the blade as you engrave). The rounder belly of a *spitsticker* was designed to facilitate the engraving of curved lines though the tool can also be used to make straight lines, making it very versatile. *Tint tools* were designed to create fine parallel lines for tonal or tinted effects; these tools were often used, in early engravings, to create subtle gradations in engraved skies and clouds. By varying the angle at which you hold most tools against the wood, you can achieve thicker and thinner lines or variations within a single line. With tint tools, however, the lines retain a more or less uniform thinness regardless of variations in the cutting angle. Gravers, spitstickers and tint tools can all also be used to create stippled dots, hatching and so on.

Multiple tools cut several fine parallel lines simultaneously. They can be useful but, if over-used, can give a rather mechanical quality to the engraving. They are also about three times the price of other tools. *Scorpers* – both round and square – were designed to create larger (round or square) stippled dots and broader marks and lines. They are also used to clear away large areas of the block's surface. A small *chisel* is also sometimes helpful for clearing away large areas of wood. It is also used to lower a portion of the block's surface slightly – this causes the lowered part to print in a less dense tone than the rest of the block when it is printed in a press; with hand-printing, this effect can be achieved without lowering the block's surface, by simply applying less pressure to the relevant part when burnishing.

Many engravers have a special sandbag on which to rest their block. This comprises two circular pieces of leather sewn together around their edges and packed tight with sand. This raises the block closer to your eye level and reduces the need for you to stoop over it. Also, a lot of engraved marks are made by moving the block beneath the tool rather than moving tool over block. This makes it necessary, for ease of movement, to lay the block on a flat smooth surface. Sandbags are available from specialist suppliers and can be useful, but you can improvise by laying the block on top of a fat book, around which is wrapped a taut piece of fabric or on which is

Right 'Enna', 52 x 52 mm, by Roy Willingham. Wood engraving on a boxwood block, printed on Zerkall paper and demonstrating a lively combination of marks applied to a very tiny block.

resting a small sheet of perspex or glass (with smoothed edges).

A cheap, hard roller is problematic for inking these blocks as it tends not to coat them evenly. You really need a (more expensive) small polyurethane or rubber roller. Water-based ink is not suitable for printing a wood engraving block as, being end-grain, water-based ink tends to make its surface swell which can distort or fill in fine marks. If desired, water-based ink can be used to print the synthetic alternatives to engraving wood.

Preparation of wood

When you buy engraving wood, one surface is beautifully smooth, ready for use. (If you want to cut down on the cost of wood, the block's opposite face can also be engraved and printed. Plane it smooth with a wood plane and polish it with increasingly fine grades of sandpaper and polishing paper. It is difficult, at home, to achieve the extreme polish and smooth finish of blocks prepared by specialists, but you can make an adequate surface which is fine for early trials of the technique.) Before you start engraving, it helps to stain the wood so you can clearly differentiate between its uncut surface and the marks you engrave on to it. Paint the smooth surface with layers of black (or dark) Indian ink. Use a square-ended paintbrush with a very small quantity of ink. Build up the degree of darkness required by repeated applications of small amounts of ink. Do not apply a lot at once or it will flood the surface; this will soak into the wood, causing it to swell, making it spongy and difficult to cut. It also defeats the purpose as ink which soaks through will stain the block beneath the surface so that marks you cut will not show up clearly. If this happens, when the Indian ink is dry, try rubbing talcum powder into the cuts. This can be brushed off with a small stiff brush (a man's shaving brush is ideal) prior to printing.

After the block has been stained, the image can be drawn onto it, directly, in pencil, or transferred using the methods described in Chapter 7; pencil marks show clearly against the darkened wood. Alternatively, some engravers paint their blocks with white gouache and draw onto the block in black ink.

Cutting

The steeper the angle of tool against wood, the more physical force you will need to make marks as you will tend to push the tool down into the wood rather than cutting across its surface. The shallower the angle you can achieve (while still maintaining control over the tool) the easier you will find it to engrave and the finer marks you will get. Push the cutting tip gently into the block until you feel it has some purchase there. Now lower your hand so that the blade is at as shallow an angle as possible to the wood; now start to push the tool forward to make a cut.

You should see a tiny curl of engraved wood peeling up at the tip of the tool as you cut. It is not usually sufficient to simply dent or score the block as these marks will quickly fill in when printed; engraved lines and dots can be exquisitely fine but they must be engraved. If engraving on wood, the tiny curl (burr) will spontaneously fall away. If working on a synthetic block you need, ideally, a 7 mm (0.3") flat chisel laid flat on the surface of the block and pushed gently across it to remove the burr, or a sharp scalpel skimmed lightly across the surface.

To make straight lines, push the tool along the block. To make curved lines, position the tool's tip in the block. Then, while gently pushing forward with the tool in one hand, use the other hand to turn the block in whatever direction is required to make the curve bend in the direction you want. To make

Below *Cup the tool's handle in your palm so that, without using your fingers, it stays in place. Let the blade project along your index finger. Close your fingers around the handle in a way which feels comfortable but avoid wrapping your fingers underneath the blade. Your little and ring fingers may tuck into the underside of the handle. Anne Desmet's tool-holding grasp is shown with new and used blocks and her tool box.*

Below *Marks made on end-grain boxwood by the tools indicated.*

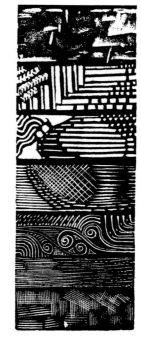

chisel

square scorper

round scorper

lozenge graver

spitsticker

tint tool

multiple tool

stippled dots, try turning the block slightly, beneath the blade, between cuts; this will vary the tool direction of each cut and might render a stippled tone livelier than if it is cut with all the marks in a single direction.

Below *Engraving a block (which is supported on a sandbag).*

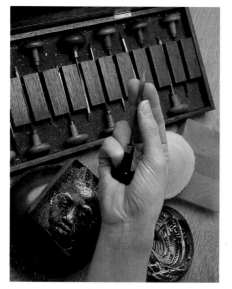

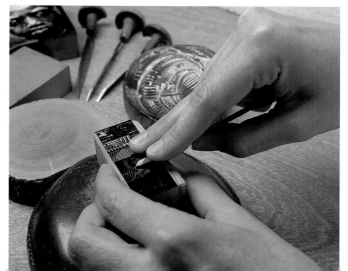

To *avoid injury remember to cut away from your body and keep your non-cutting hand well clear of the blade.* The only way to discover the enormous variety of marks which can be engraved is to use all the tools at your disposal; experiment with varying the pressure exerted on different blades and juxtapose and combine different tool marks.

smooth, fine paper – Japanese tissues such as *Hosho* or *China White* are ideal as they take excellent impressions and adhere well to the block during printing – but, with careful handling, thicker papers, such as *Gampi Vellum* or *Zerkall*, can also be hand-burnished. *Inking and printing are done using the single or multiple block methods as described in Chapter 7.

Printing

Roll out a very small amount of oil-based ink on the slab (use a bit less ink than you would put toothpaste on your toothbrush and add more, as required, between printings); roll it thoroughly until it forms a thin satiny sheen on the slab and the roller makes a gentle hissing sound as you roll it across the ink*. Printing can be done with a spoon or similar burnishing tool on to

Cleaning

If the cutting is fairly broad and not too clogged with ink, the block can simply be burnished a few times (without re-inking between printings) on to newsprint and left to dry. Alternatively, dab the block with a ball of 'stick-up putty' (available from stationery shops for fixing posters to indoor walls). The putty lifts the ink off the block and is an excellent way of cleaning ink-clogged areas.

Above *'Tape Fish', 60 x 140 mm, by Mandy Bonnell. In this wood engraving, the artist combined the use of traditional engraving tools with a roulette wheel (an etching tool), with which she indented a pattern of minute dots. She also distresses and applies texture to her blocks with sandpaper and wire wool and stabs them with an etching needle (a compass point would also suffice) to create dots. This impression was printed onto China white laid paper by burnishing with a teaspoon.*

101

The block can also be cleaned with a drop of white spirit on a rag to prevent ink from drying in the cuts. Do not use much solvent or its surface may swell. After cleaning the wood with solvent, it will be too spongy to engrave for as much as a day; further printing should be delayed for at least that time as the residual solvent tends to repel printing ink.

Care/sharpening of tools

It is important to maintain tools in good, sharpened condition. A blunt tool is hard to use and may slip on the block while you are cutting – which could harm both you and the block. Care for tools, when not in use, by storing them in a fabric roll (illustrated on page 70) or in a baize or felt-lined box. To prevent rusting, wipe the blades occasionally with an oily rag.

Above *Sharpen only the face of an engraving tool, not its back or sides or you will distort its shape. Hold it with its handle in your palm and its blade pointing downwards so that its face lies flush with the surface of an oiled Carborundum or India stone. Rub the blade's face over the stone's surface using a figure of 8 motion and remove any burr from the metal by rubbing the cutting edges lightly across a finer, smoother stone (such as Arkansas or Washita) or a very fine grade of wet and dry paper. Test the tool on a spare wood block and continue sharpening until it cuts easily.*

102

10 Stencilling

The stencil is the basis of the most primitive but highly effective print techniques (stencilled images have been found on prehistoric cave walls). It can produce striking images either on its own or in combination with other print methods.

To make stencils you need: thin card or reasonably stiff paper; a pencil; a sharp craft knife; water-colour, poster paint, printing ink or liquid ink; printing paper; and devices to apply ink such as a sponge, child's paintbrush, shaving brush, old toothbrush, nailbrush, atomiser or spray. Each device produces different printed effects on paper or other surfaces such as furniture, china or textiles.

Above *Draw a design onto cardboard then cut out, with the craft knife, the shapes you have drawn. (Protect your worktop with a thick piece of cardboard when cutting.) Keep the parts you have cut out, as well as the stencil itself; the offcuts may make useful new stencils. Place the finished stencil onto the printing paper then stipple ink or paint through or around the cut-out shapes.*

Left *'Dead Trees Sheppey', 186 x 166 mm, wood engraving by Monica Poole demonstrates extraordinarily fine mark-making and the subtle, tonal possibilities to which wood engraving lends itself.*

Below *'Dinosaurs', 185 x 465 mm, by Max Halstead (age 4) with help from his mummy. The stencils were made from thin card and printed with runny poster paint applied with a brush.*

103

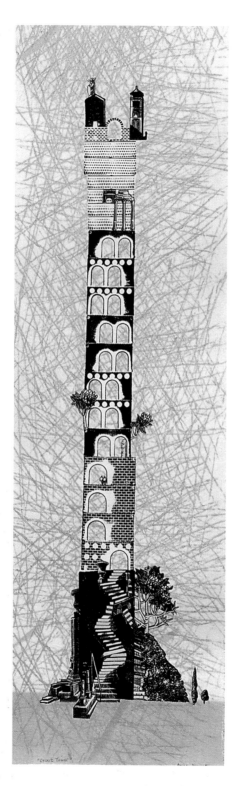

Right *'Desert Tower',
425 x 124 mm,
mixed-media mono-
print by Anne
Desmet. The pedestal
of the tower was
printed from an
uncut woodblock; the
jagged, rocky buttress
is a rubbing from a
piece of roofing slate;
the tower's main
structure was made
from repeated
printings of facets of
a tiny, plastic, toy
house. The textured
amber background
was made by a roller,
with string wrapped
around the rubber,
which was inked and
rolled directly onto
the print - having
first masked out the
tower area with a
paper stencil. The
image was completed
by collaging in small
pieces of the artist's
wood engravings.*

Useful tips for stencilling

1 Paint or ink should not be
too runny or it will tend to
ooze under the stencil.

2 When you are stippling or
sponging or toothbrushing
through the stencil, for best
results don't use too much ink.
Use less than you think you will
need; you can always stipple
more later if required.

Stencilling with a spray

To stencil with a spray or atomiser
use a liquid ink such as Indian ink,
dilute watercolour, or dilute poster
paint. This is messy so use old
newspapers to protect your work
surface and all areas of the printing
paper that you do not want sprayed.

You can achieve a similar effect
by scraping the bristles of an inked
nailbrush or toothbrush (with a
piece of stiff card for a scraper)
through a stencil, on to the paper.
Remember to splatter the ink away
from your body.

Right *'Mary's Mantle no. 1', 1120 x 760 mm,
© Elaine Kowalsky, is an image built up in
seventeen layers of multiple, over-printed stencils
including paper doilies printed on Somerset
satin 250 gsm paper with oil-based inks.
While the ink was still wet, the print was
dusted with very fine ground glass to give
a subtle shimmering effect. The work was
then sprayed with a light varnish.*

11 Screenprints with paper stencils

Screenprinting (or serigraphy) produces eye-catching images as simple or as complex as you like. It is an excellent way of producing colourful images and is also useful for mass-production of cards, posters or for printing on fabrics (such as T-shirts).

Screenprinting has developed from stencilling techniques – such as those used to embellish certain Japanese woodblock prints since the early 18th century. The design of the screenprinted image is determined by a stencil which, at its simplest, is a shape cut or torn out of thin paper and laid beneath the screen. The stencil blocks the ink which only passes through the mesh where it is not masked by the stencil. There are many ways of making screenprints but using paper stencils offers a versatile, distinctive way of image-making and is perhaps the method most easily undertaken within the home. The screen consists of a fine mesh (historically of silk but now more usually a man-made fibre) stretched taut over a wooden or metal frame. The frame is usually hinged to a board. To create the print, ink is forced through this mesh on to paper (or fabric, plastic, metal etc.) beneath it, using a squeegee. A squeegee is a straight piece of firm rubber or plastic mounted on a wooden handle. Screenprinting frames (with ready-stretched mesh), squeegees, water-based ink and reducing mediums for screenprinting can be bought at printmaking suppliers. Make sure that the length of your squeegee is slightly less than the width of the mesh, so that it will fit comfortably within the frame's surround. The frames do not usually come with base-board attached but you can often buy hinges with the frame (or use ordinary door hinges) to attach it to your own flat piece of board. The board should be the same size or slightly bigger than the outside dimensions of the frame.

It is, in fact, perfectly possible to make your own frame at virtually no cost and with minimal DIY skills. For instance, an old window-frame can be used. Choose a hard wood of at least 50 mm^2 in section.

Making your own screenprinting frame

1 The frame must be strong and must not be warped.

2 The mesh must be attached securely, with drum-like tautness.

106

Right *Construct a frame at least 75 mm longer in each direction than the largest dimensions of your planned screenprints. Fix the corners with rigid, flush, smooth joints. Joints can be glued and/or screwed but make sure all screws are either counter-sunk or flush with the surface.*

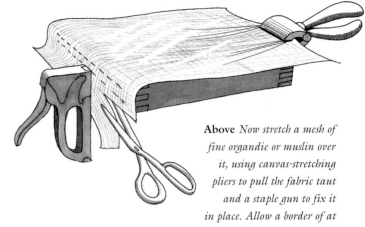

3 The frame should not be smaller than about 400 mm² since a tiny frame restricts the scale at which you can work.

Tools and equipment

To make a screenprint you will need:

- a screenprinting frame
- squeegee
- screenprinting ink (water-based)
- reducing medium (optional) for thinning water-based ink
- old tin cans or small jars
- palette knife
- scissors and/or sharp knife
- damp sponge
- gummed brown paper tape (gum strip) – tape width should be at least 50 mm
- masking tape
- smooth paper such as kitchen greaseproof paper or blank newspaper (printed newspapers will not do as their ink will transfer to the print)
- smooth printing paper such as Somerset satin, cartridge, or lightweight mount card, or fabric, ceramic etc
- old dish-washing brush

Above *Now stretch a mesh of fine organdie or muslin over it, using canvas-stretching pliers to pull the fabric taut and a staple gun to fix it in place. Allow a border of at least 75 mm excess fabric all around - to give you plenty to grip and pull taut. Staple the material to the sides of the frame, starting from the centre of each side and working outwards. The mesh should be evenly stretched and drum-tight or it will not print properly. When it is firmly secured, trim off any excess fabric.*

Right *Take a smooth, warp-free board (a piece of old kitchen melamine is ideal, or medium density fibre-board) proportionately larger than the screen and fix a length of wood along one end. This wood strip should be 5mm taller (in section) than the wood of the frame. Attach the frame (mesh side down) to the board base using split hinges; these facilitate easy removal of the frame for cleaning. Glue small wooden "feet" of about 5 mm in depth - one at each corner of the frame. These raise the screen slightly above the surface of the base, allowing the mesh to "snap" away from the printing surface as the print is pulled; this helps to ensure a crisp, clear print.*

Right *Moisten the tape's adhesive with a damp sponge and stick it down along all four sides, pushing it right into the edges where mesh meets frame. Then stick a further layer of tape, along all four sides, on the flat of the mesh. The tape strengthens the joins where mesh meets frame, provides a border for your image, and makes a ledge on which excess ink can rest – stopping it from oozing through the edges of the frame. (After printing, the tape can either be left in place or removed by re-moistening it with water and peeling it off. Surprisingly, gum strip seems to stay in place even when printing with water-based inks. If you flood the screen with water, during its cleaning, the tape will come off, but if you use water sparingly it will stay in place.)*

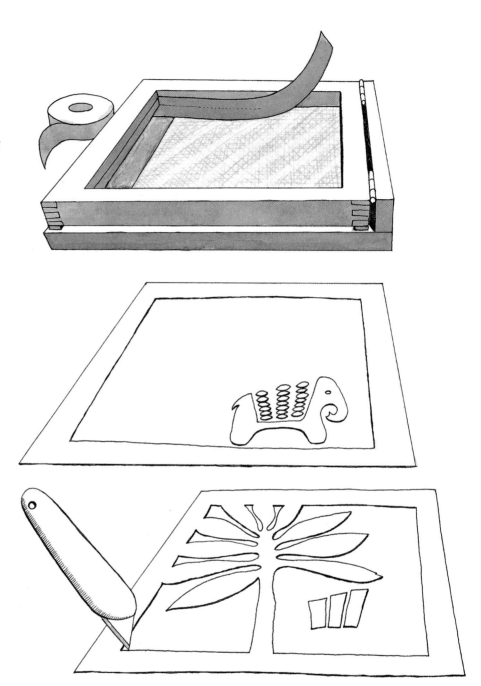

Above *Cut a rectangle of paper slightly larger than the tape 'window'. Draw a design onto it making sure that the image is no larger than the space available within the 'window frame'. Try to base your design on strong shapes rather than lines and, at this stage, the drawn shapes should not overlap one another. Once drawn, cut or tear out the areas which are to be in colour: the stencil is the portion of paper which remains after you have cut away the excess (but keep the bits you cut out as they may make useful additional stencils later). Two separate stencils are shown here – the components of Sarah Hamilton's image (on facing page).*

108

Screen preparation and stencil-making

1 The screen should be clean and free of grease. Scrub it (not too hard or you will tear it) with washing-up liquid and a dish-washing brush before rinsing with plenty of clean water.

2 Leave it to dry. If you are in a hurry, use a hairdryer or electric fan heater or lean the screen against a warm radiator, but make sure you lay down newspapers to protect the floor.

3 When the mesh is completely dry, its edges, where it joins the frame, should be reinforced with gum strip. Avoid self-adhesive tapes as these can be difficult to remove.

4 Now see facing page for illustrations of applying gum strip and making stencils.

Printing

Cut, to precisely the same size, as many pieces of printing paper as you need for your planned total number of prints but allow a few extras for misprints. In a clean can or jar, mix inks to your choice of colour with a palette knife. The inks usually come in a ready-to-use consistency but, if too thick, most water-based inks are best thinned with special reducing medium available from printmaking suppliers though water will usually do if no other medium is available. Thin the ink to the consistency of thick, pouring cream with no lumps. (Be careful to add reducing medium just a little at a time, so you don't inadvertently make the ink too runny.) To test if the ink is ready to print, lift a blob on to your palette knife then let it drip back on to the surface of the pool. The drop should sit for a moment on the ink's surface before sinking back into the pool. Now see page 110 for an illustrated description of the printing process.

The stickiness of the ink will fix the stencil to the mesh and the printing process can be repeated as many times as desired. (It may require two or three printings before the ink builds up to full strength.) Once you have finished printing, peel off the stencil and wash the screen thoroughly with water and an old washing-up brush.

Below Untitled, *192 x 192 mm, by Sarah Hamilton, was printed on Arches 350 gsm paper, in water-based inks, using two paper stencils printed one after the other to produce a two-colour image with a third colour where her semi-transparent hues overlap.*

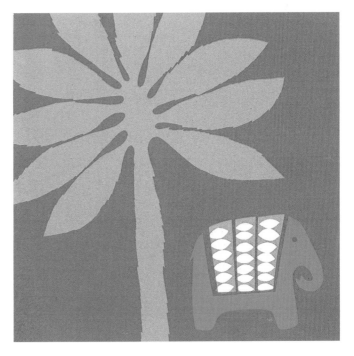

Right *Place the first sheet of*
paper onto the base of the frame.
Mark its position with masking
tape around one corner and along
one edge. Leave these markers in place
to enable you to position each subsequent
sheet in precisely the right place.
When the paper is in
position, place the
stencil onto it.
When you place the
screen mesh over the
paper, the stencil should
lie neatly within the 'window'
made by the brown tape.

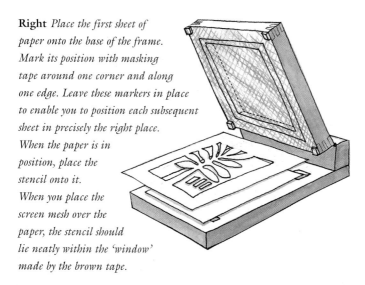

Printing with more than one colour

After the screen has been washed and dried from your first printing, cut a new stencil, lay it over one of your single-coloured prints then print on to it again, as described, but using a different colour. Wonderful effects can be obtained where two semi-transparent hues overlap and produce a third colour. You can overprint your original single-colour print with as many new stencils and colours as you wish. When printing more than one colour, it is particularly important that the paper should always be positioned in exactly the same place, relative to the screen (hence the need for the tape markers on the base), so that all subsequent printings will be correctly registered in relation to the first.

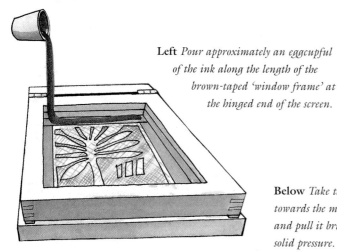

Left *Pour approximately an eggcupful*
of the ink along the length of the
brown-taped 'window frame' at
the hinged end of the screen.

Below *Take the squeegee and, holding it at a slight angle*
towards the mesh, place its rubber blade behind the strip of ink
and pull it briskly and firmly across the screen with an even,
solid pressure. The ink will be forced through the mesh and onto
the paper in all areas where it is not masked by the stencil.

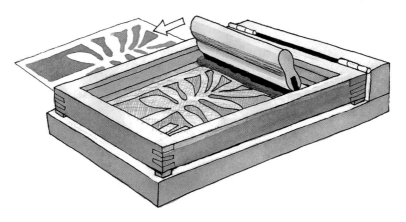

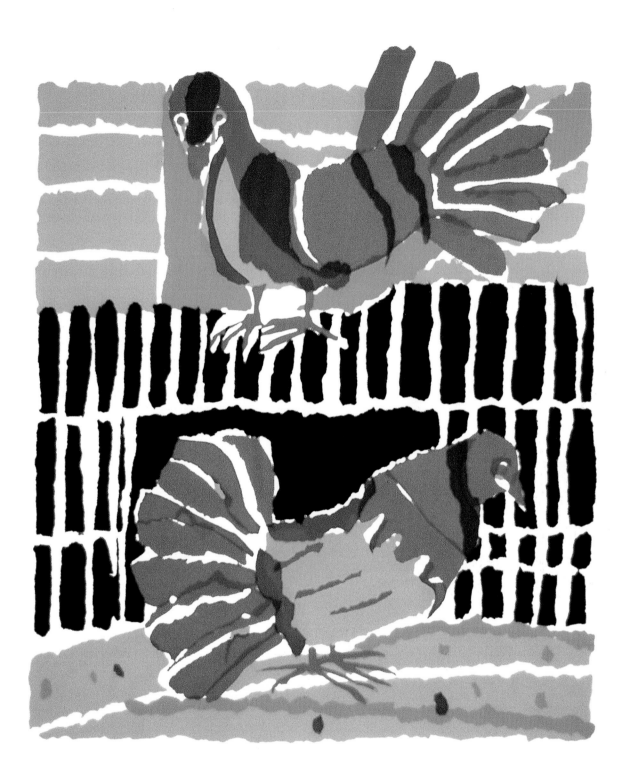

Above *'Dad's Pigeons', 425 x 350 mm, by Penny Grist.*
Screenprint in several colours using cut and torn paper
stencils, printed on Somerset satin paper.

12 Unique prints (monotypes)

Below *This mirror-image blot insect, 165 x 220 mm, was made using drawing inks.*

A monotype is a one-off print: a unique impression printed off card, glass, perspex, metal or any other flat surface. It cannot be repeated in an identical form as it is not made from a block or other semi-permanent printing matrix. As one-off prints are quick and easy to make and can create rich results, its techniques are seductive. They are arguably less versatile than other methods as the image cannot be repeated or printed in different ways – there being no printing block with which to experiment. One-off prints do, however, have their own particular, characterful qualities and are well worth making.

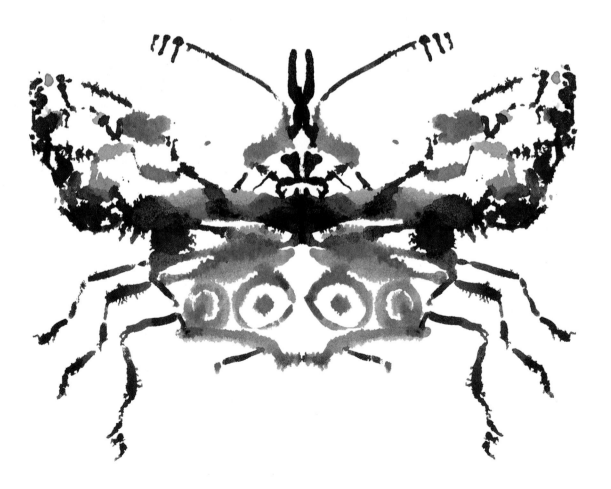

For all monotype methods it is essential to work fairly quickly so that the ink or paint does not dry out before you have finished.

MIRROR-IMAGE BLOT

This is a good way of making a symmetrical image along either side of the fold of, for instance, a card or one-off, concertina-folded, artist's book. Take a thin, smooth piece of card (or stiff paper) and fold it down the middle. Open it out and paint random marks on to one half of the fold using liquid drawing ink (or watercolour/gouache/poster paint of the consistency of pouring cream), keeping the ink/paint as wet as possible. Work quickly; allow some marks to dribble right up to the fold. Try dripping ink on to the paper then blow it with a straw to create random spidery lines. When you have finished each colour – or as soon as any of the ink starts to dry – close the card and press it down firmly, by hand, so ink is transferred from the inked to the uninked surface.

Above *'Alien', 187 x 265 mm, by Louisa Desmet (age 9). Mirror-image blot using diluted poster-paints.*

MONOTYPE DRAWING

This is a quick, effective way of creating fine-lined drawings with attractive random areas of tone. It is a technique much used by well known artists of this century including, notably, Paul Klee (1879–1940). Roll out a thin, even coating of ink, to form an approximate square or rectangle on the slab. The ink should have a smooth, satiny look with no bits of fluff or dust in it. Oil-based ink is easier to use for this as it stays wet longer than water-based. However, if using water-based ink, its drying time will be lengthened if you add one or two drops of household washing-up liquid to it, which should be well mixed on the slab, before you roll it out. See facing page for an illustrated description of making a monotype drawing.

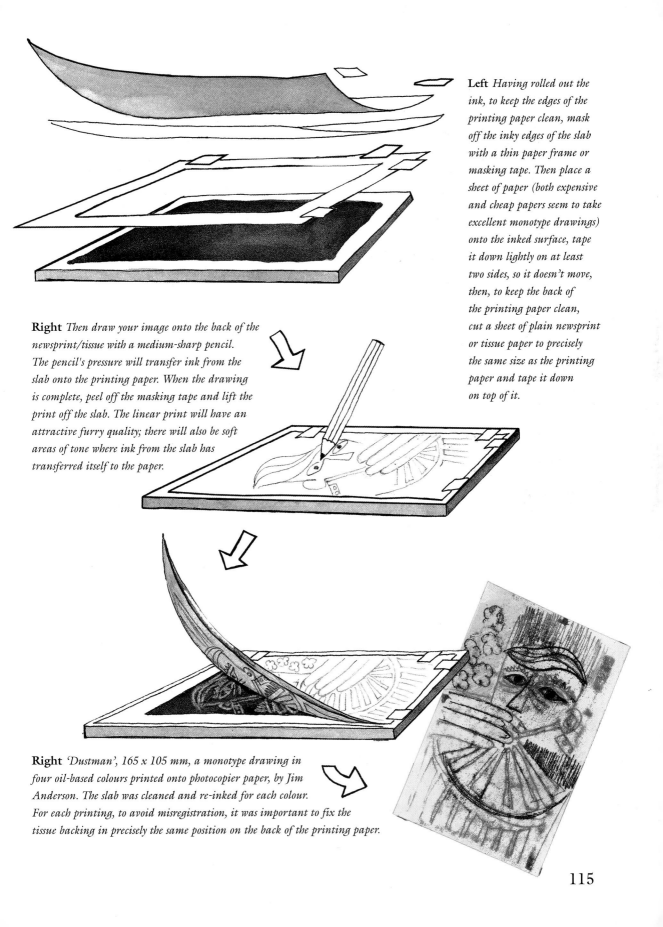

Left *Having rolled out the ink, to keep the edges of the printing paper clean, mask off the inky edges of the slab with a thin paper frame or masking tape. Then place a sheet of paper (both expensive and cheap papers seem to take excellent monotype drawings) onto the inked surface, tape it down lightly on at least two sides, so it doesn't move, then, to keep the back of the printing paper clean, cut a sheet of plain newsprint or tissue paper to precisely the same size as the printing paper and tape it down on top of it.*

Right *Then draw your image onto the back of the newsprint/tissue with a medium-sharp pencil. The pencil's pressure will transfer ink from the slab onto the printing paper. When the drawing is complete, peel off the masking tape and lift the print off the slab. The linear print will have an attractive furry quality; there will also be soft areas of tone where ink from the slab has transferred itself to the paper.*

Right *'Dustman', 165 x 105 mm, a monotype drawing in four oil-based colours printed onto photocopier paper, by Jim Anderson. The slab was cleaned and re-inked for each colour. For each printing, to avoid misregistration, it was important to fix the tissue backing in precisely the same position on the back of the printing paper.*

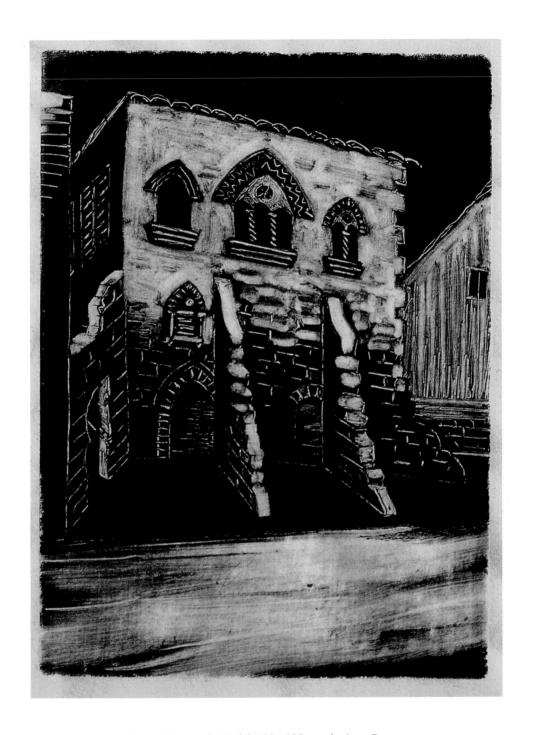

Above *'Syracuse by Night', 170 x 125 mm, by Anne Desmet, is a monotype produced by the wiping method. The image was drawn directly in the wet ink with a pencil, a cotton bud and a rag. It is shown here at actual size.*

WIPING METHOD

This is another quick and easy technique and can produce a more textural image with unusual drawing implements. Like the other mono-type methods, it will only produce a single image. You need a slab with ink rolled out on it as for monotype drawing but instead of drawing through a sheet of paper laid on the ink, draw directly into the wet ink. You can make marks with a variety of materials, from a fine, spidery line drawn with a pencil to the scratchy, brushed texture made by an old paintbrush, to broad, sweeping areas of tone and texture created by rubbing the ink with a rag, cotton bud or finger. Assuming you are printing on white paper, remember that the marks you make will be the white areas of the print which will also be a mirror-image of the drawing on the slab.

When your image is complete and before the ink starts to dry, lay a clean sheet of smooth printing paper on to it. (As for monotype drawing, mask off inky edges of the slab with a paper frame or masking tape before positioning the printing paper.) Tape the paper lightly in place with masking tape along two of its sides and burnish the back of it with a spoon. From time to time, lift a corner to check whether the image has fully transferred. When it has printed to your satisfaction, peel off the tape (taking care not to tear the paper) and lift off the finished print.

TRANSFER PAINTING

This method is as close as printing comes to traditional painting – as a transfer monotype is, essentially, a squashed painting. For this method, again, you must work fairly fast. If using water-based ink, add a couple of drops of washing-up liquid to it when mixing your colour, as the ink will not then dry up so readily. Most varieties of printing ink and not-too-runny paints should work, though all will have different qualities. To make a transfer monotype, simply paint a picture on a clean slab using thick colour. Apply as many colours as you like with brushes, rags or fingers as preferred. When the image is complete (or if any areas are showing signs of drying), place a sheet of paper face-down onto it and print by spoon-burnishing. The resulting impression will be a slightly softened and 'squashed' mirror-image of the painting on the slab.

Above *'Quantock Hills', 330 x 700 mm, screenprinted monotype by Judy Willoughby. The image was painted onto a screen using water-based inks. To print it, the ink was forced through the mesh using brushes and pieces of card. This is a variation of the transfer painting process and, like that method, the print can be created in stages, overprinting new colours and imagery as desired.*

You may find it easier to create your transfer painting in stages, printing each colour, one at a time.

To print in stages:

1 hinge to the slab a clean sheet of printing paper with masking tape along one edge, thus ensuring that it remains in place for successive printings. Do this before applying ink to the slab as it is easier to position the paper correctly while the slab is clean.

2 Lift the hinged paper away from the slab (like turning a page of a book) before starting to paint your image. Lay some newspaper or plastic sheeting on top of the turned-back 'page' to keep it clean from paint splashes while you are working.

3 Start painting your image on to the slab but, as you finish using one colour or complete a small area, before adding more paint, turn the printing paper back down on to the slab, print it by spoon-burnishing then turn the 'page' back again before adding more marks and colours on the slab. This way you can afford to work more slowly, building up the image by successive printings, before the ink has a chance to dry up each time.

4 If you find that some areas have not printed to your satisfaction, add more colour to the relevant parts on the slab and press the paper down once more.

5 When the print is complete, carefully peel off the masking tape hinges and lift off the paper.

13 Fabric printing

You need not be limited to printing on paper. It is easy to use many of the techniques described for printing on fabric. Use purpose-made fabric paints for printing on textiles as printing inks or paints designed for use on paper may not necessarily produce satisfactory results on fabric: peeling, cracking, fading and running-when-washed are all problems which can occur if you don't use purpose-made paints. However, fabric paints are readily available from good art and craft shops and are easy to use for print-making purposes.

To print on fabric:

1 Choose a relatively smooth, evenly textured material to print on, for example, cotton or cotton/nylon mix, silk, velvet or linen. Avoid extremely fibrous or textured materials such as woollens, hessian or lace.

2 Wash and iron the fabric before printing on it.

3 The material should be kept smooth and stretched flat during printing.

a A T-shirt can be stretched over a rectangle of cardboard. This has the added advantage of protecting the back of the shirt from any excess ink seeping through from the front during printing.

b If you are printing on a length of fabric, for example, a tea towel, it is a good idea to stretch it out on a thick piece of cardboard, fixing it in place with drawing pins or thumb tacks.

c If printing on a large piece of fabric, for example, a sheet, pin it to a piece of cardboard (as for a tea towel), section by section, and print on each stretched section in turn.

4 As printing on fabric can be unpredictable, if possible, try out a test print on a sample of fabric. This is important if you are using expensive or large expanses of material – it may save you both unnecessary cost or wasted time, should you be unlucky enough to discover that your selected fabric can not be printed

Right *Art student
Stacey Chapman
made a print of her
car. She inked it with
rollers, using artists'
acrylic paint mixed
with extender to slow
down the paint's
drying time as the
car took about three
hours to ink. Once
inked, the calico
fabric was laid
in place.*

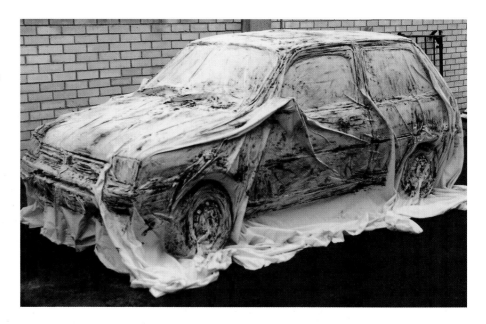

Above *Fabric design sample, 430 x 700 mm by Carolyn Abbott (textile design student). Linocut
pattern made from two small blocks printed by hand-pressure onto a textured Indian paper. The
blocks were first inked and printed in pink; they were then cleaned, re-inked and printed in blue.*

122

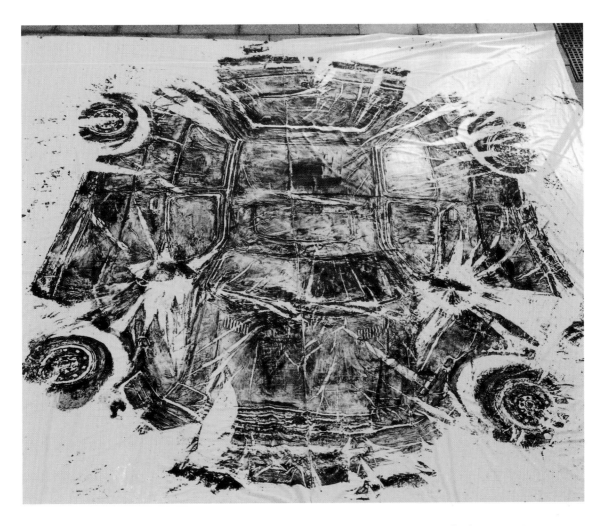

satisfactorily. If you have not printed on fabric before, start by printing on an old pillowcase or some other fabric which can be thrown away without worry if the printing is unsuccessful.

5 It is extremely difficult to spoon-burnish on to fabric. So, if you want to print by any block printing methods, such as lino or potato printing, these should be printed by simple hand-pressure.

6 For some methods you may find that you need to apply more ink to the printer than is necessary for printing on paper, in order to achieve a successful fabric print.

7 Once dry, most kinds of fabric paint need to be fixed with an iron. Follow the manufacturer's instructions. Cover the printed fabric with a clean scrap of material and iron over the top. You may find that some ink transfers from your printed fabric to your scrap material.

Above *'Car',*
c. 5400 x 3900 mm,
by Stacey Chapman,
printed on calico.
The fabric was spoon-
burnished by a group
of students. Water
applied with a fire-
hose was used to
clean the acrylic
paint off the car once
this huge print had
been peeled off it.

123

14 Ceramic printing

A lot of printing techniques can be used for printing on clay and china as well as paper. You can print on ceramic tiles, terracotta plant pots, old dinner plates – or directly on to wet clay to create an embossed effect. Use purpose-made ceramic paint or potter's glaze. Of the former, there are various types – both oil-based and water-based. Oil-based glaze fixes as it dries whereas water-based glaze needs to be fired in an oven. (The firing can be done, at fairly low temperatures, in an ordinary household oven.)

Right *Artists' acrylics were used for printing stencilled designs onto this terracotta pot. This paint dries very quickly so is not suitable for other printing techniques. Acrylic paint keeps its colour well, does not need firing and will even withstand weathering, if the pot is for use outdoors. It should not, however, be used to print on glazed ceramics as, once it dries, it will peel or flake off the surface.*

Whichever kind you use, ensure you follow the manufacturer's instructions closely, or your image may quickly scratch or wash off china. The ink on home-printed ceramics may not survive the rigours of domestic use and, as its components may contain toxins, eating off hand-decorated plates is not recommended.

Printing methods which are particularly suitable for printing on china/ceramics are: stencilling; screenprinting (for flat tiles only); eraser prints; and small cardboard prints. Simple but striking shapes can be cut out of sponge and printed on to ceramics using the sponge as a printer.

Printing on damp clay

Interesting embossed prints can be made using damp clay. The clay should be leatherhard: firm but not set. Roll it into a reasonably flat slab and press into its surface – without ink – some of your small lino or collage blocks or bits and pieces such as bottle tops, buttons, keys, dried pasta, coins, seashells etc. Hand-pressure will be sufficient for printing, then lift off each printer. Each will have left a perfect, colourless, embossed impression of itself in the damp clay which can be left to dry (and baked hard, if required).

Left *'Tessilating Waves', 152 x 218 mm, encaustic tile made from a linocut by Ellen Hanceri. The artist mounted her lino block on board to make it up to the depth of a tile. She made a plaster mould from the mounted block. Into this mould (when dry) she brushed terracotta slip. Before this was fully dry she pressed in terracotta clay until it was flush with the edge of the mould and smoothed it to a flat surface. Once the clay had shrunk a little from the mould, it was turned out to reveal an imprint of the linocut in the clay. She then surrounded the damp tile with a 'wall' of wet newspaper and poured a white liquid slip onto its surface. When this was leather-hard, she scraped back the slip to the level where the linocut image showed through. The tile was then fired in a kiln.*

Printing on fired clay

1 If printing on to china (rather than wet clay) make sure the china is clean and dry.

2 Try out a small test print first (for instance try printing on to the underside of your plant pot or the base of your plate).

3 If you make a mistake while printing on a glazed ceramic you can quickly wipe off the error with a solvent or water (depending on what kind of ceramic paint you are using).

4 If using oil-based paints – protect your work surface with plenty of old newspapers; wear an apron to protect your clothes; have vegetable oil (or white spirit) and clean rags available for wiping up errors and paint spillages and for cleaning up afterwards.

5 Rub barrier cream on your hands, before using oil-based paint, as it can then easily be washed off the skin with ordinary washing-up liquid or soap and water. Wear rubber gloves when cleaning up oil-based inks or paints – as you should never allow solvents to come in contact with your skin.

6 Oil-based ceramic paint fixes as it dries whereas water-based ceramic paint needs to be baked in an oven, as per the manufacturer's instructions.

7 You can substitute polymer clay (as described in Chapter 5) in place of normal clay.

15 Combining print & collage

Below *'Building the Viale Foro Imperiale', 120 x 305 x 6 mm, by Anne Desmet. This comprises details of the artist's wood engravings and linocuts printed on various coloured and tinted papers and combined with bits of an Italian banknote - all collaged onto a painted, gessoed, wood panel.*

In trying out techniques in this book you will undoubtedly print many 'proofs' (test prints), or simply more copies of some prints than you want. Don't throw these away. They can be used for collage-making. Multiple prints of the same image can be cut up to supply repeat elements which might form the building blocks of a new work. You can assemble, in collage, elements from your own prints combined with other printed materials. Collaging prints produces one-off printed images which are often suggested by and develop the themes of the original prints. It is possible to make collage prints in both two and three dimensions and to combine different papers and other materials in their construction, as well as elements of drawing and painting.

Collage is a large subject which can only be touched on in these few pages. Here, however, are a few factors to bear in mind.

1 Cheaper papers tend to be acidic and will brown and grow brittle with age. The colours of printed ephemera (bus tickets, magazine illustrations etc.) may fade with time so, be careful, when assembling the various elements for your collage, not to include one piece which quickly deteriorates amongst other more durable materials. You can, to a certain extent, test the light-fastness of printed ephemera and coloured papers by hanging a sample in a sunny window for a few weeks or months (and placing a control

sample of the same paper in a dark drawer for the same period). After a reasonable time has elapsed, compare the samples to see if fading has occurred in the one exposed to sunlight. If you intend to practise the art of collage professionally, it is adviseable to test the acidity or alkinity of papers to be used – instructions for which can be found in specialist collage manuals.

2 Glues and adhesive tapes should be selected with care. Rubber-based glues brown with age and the colour may seep through to the front of your collage. Find a non-toxic, water-washable glue with a neutral or nearly neutral pH value or invest in an approved conservation-standard/archival glue. Archival glues are often made from wheat, rice or synthetic starch and can be made up (to particular recipes) from dry ingredients or purchased ready-made from specialist suppliers of conservation materials (and some art materials shops). The gum on tapes such as masking tape, sticky tape and equivalents brown and lose their tackiness with time so are not suitable for collage-making as they can discolour papers and, over time, may come unstuck. If tape is required, choose a specialist, paper-backed, water-soluble or reversible conservation tape.

Above *'Thirty pieces of wood', 266 x 330 mm, by Anne Desmet. Thirty pencils, inked and printed by hand-pressure onto Somerset satin 300 gsm paper, were turned into trees by adding collaged pieces of the artist's wood engravings. The blue shadows were made from Amaretti wrappers.*

3 Most glues will cause paper materials to cockle as they dry. To avoid this, press your collage flat under weights while it dries.

4 Papers expand and contract at different rates and are highly susceptible to normal atmospheric changes in temperature and humidity. You will notice this particularly if you collage a heavy-weight paper to a much lighter-weight piece. Even if you press the collage flat to dry you may notice that, although at first it may flatten completely, slight cockling may occur within only a few weeks or, worse, the glued papers may start to pull apart as they 'breathe' at different rates. This danger can be reduced (but not eradicated) by selecting similar weights of paper to collage together or, if using mixed paper types, by ensuring that the paper support, especially for a large work, is of a heavier weight or similar weight to papers collaged on to it.

Right 'Matera', 200 x 162 mm, by Anne Desmet. This composition recalls a town carved into a rockface in Southern Italy. Its basis was a piece of roofing slate inked and printed onto an Indian red/brown paper. Onto this the artist collaged fragments of her wood engravings as well as tiny pieces of gold leaf.

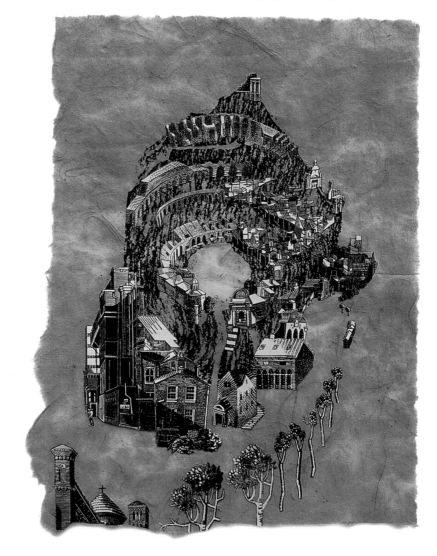

Glossary of terms, techniques & materials

Acid-free: neutral pH state shown on a scale 0-14, from acidity to alkilinity. pH7.0 is neutral. The term is used with particular reference to paper and archival glues and tapes.

Baren: traditional, Japanese, hand-held, disc-shaped pad used for producing a relief print by burnishing the back of the printing paper when it is laid on the inked block.

Boxwood: hardwood made into end-grain blocks for wood engraving.

Caustic soda etch: corrosive alkali (sodium hydroxide) solution; can be used as a mordant to etch a granular texture onto linoleum.

Chisel: tool for wood engraving, woodcutting or linocutting; generally used for cutting away large areas of a block's surface.

Collage block: assemblage of paper, card and/or other materials glued to a backing board. It can be printed either in relief (or, with a printing press, in intaglio).

Collagraph: print made from a collaged block.

End-grain: a block of hardwood sawn across the trunk and used for the technique of wood engraving in which the cuts made run at right angles to the grain of the block.

Engraving: general term for the act of incising marks, the incised block itself and any prints taken from it.

Etching: general term for the process of using a mordant to bite the surface of a printing plate (usually metal or linoleum), the etched plate itself and any prints taken from it.

Etching needle: sharp metal tool (similar in appearance to a knitting needle but with a sharp point) used, usually, for scratching designs onto a metal plate for printing by the intaglio process. The tool is also useful for mark-making using other print processes.

Extender (tinting and reducing medium): transparent additive to ink which dilutes the pigment

colour while maintaining the correct consistency for rolling.

Gesso: mixture of plaster of Paris and glue which can be applied to a surface to create a smooth or textured layer.

Grain: directional pattern of fibres in wood.

Graver/burin: tool used in wood (and copper) engraving; square or lozenge-shaped in section, it is usually used for engraving straight lines of varying thicknesses.

Hand-burnishing: method of printing a block with a hard, smooth, hand-held implement such as a wooden or metal spoon or baren which is used to apply pressure by rubbing the back of paper laid, face down, on the inked block.

Hand/foot pressure: method of printing a relief block by applying pressure with hand or foot to transfer an inked impression from block to paper.

HP (hot pressed), **Not** or **CP** (cold pressed) & **Rough:** different surfaces of paper produced by different manufacturing processes.

Imprint/impression: a print applied on any surface.

Ink (printing): pigment suspended in a semi-liquid oil-based or water-based medium, prepared to a particular consistency and malleability suitable for printing.

Inking slab: smooth hard surface (such as glass or marble) used for mixing, spreading and rolling out ink.

Intaglio print: imprint produced by a method in which ink is rubbed into the grooves on a (usually metal or collaged) printing plate and printing is carried out, often on dampened paper, using an etching press to force the dampened printing paper into the inked grooves of the plate, to pick up the impression.

Japanese paper: strong, handmade paper made from the long fibres of mulberry bark and other indigenous Japanese plants; it is particularly good for burnished prints.

Jigsaw block: printing block cut up into entirely separate pieces which are usually inked in different colours and reassembled, like a jigsaw, in the printing.

Laid paper: the imprint of light lines produced by the wires comprising the mesh base of a mould for handmade paper; it is also imitated in machine-made papers.

Limited edition: finite number of identical prints, each of which is numbered as part of the total.

Linocut: a print produced from a linoleum block.

Marbling: process of printing (usually patterns and textures) using a suspension of oil-based inks in water.

Matrix: general term for a printer, printing block or printing plate.

Mixed media: artists' prints which combine more than one basic method, eg linocutting and stencilling.

Monochrome print: a print in just one colour.

Monoprint: an impression printed from a reprintable block such as a lino block, but printed in such a way that only one of its kind exists, for example, an image incorporating unique hand-colouring/collage/monotype.

Monotype: a one-off print, a unique impression printed off card, glass, perspex, metal or any other flat surface; it cannot be repeated in an identical form as it is not made from a block or other semi-permanent printing matrix.

Multiple-block printing: method using more than one block to produce an image – usually involving overlapping areas of colour or tone.

Multiple tool: tool for wood engraving. Its cutting edge comprises at least two (often more) tiny 'teeth'; it is used for cutting several parallel lines at once – as many lines as the tool has 'teeth'.

Offset printing: method of transferring a still-wet impression from one block to another. It is often used as a helpful means to determine the cutting in multiple-block prints.

Plate (printing): general term for a sheet of metal, plastic etc from which a print is taken; it is largely interchangeable with **Block** or **Printer** but is usually used to describe thinner printers than blocks.

Polymer clay: synthetic modelling clay made and marketed for children's use but also a versatile material for use as a printing surface or matrix.

Pounce/dolly: inking implement (often home-made) comprising a small piece of soft fabric or leather packed drum-tight with rags (or any soft fibre) and tied (like a sack) at one end.

Printing press: machine, either hand-operated or mechanised, designed to print repeatable impressions.

Printer/printing block: general term for a piece of linoleum, wood, card etc from which a print is taken.

Printing/printmaking: process of transferring an impression from one object onto the surface of another – rather than directly painting or drawing a mark.

Proofs: trial impressions taken prior to editioning a finalised version of an image.

Reducing medium: substance used to extend ink or paint to reduce its opacity and thereby extend its transparency. Different mediums are used depending on the properties of the ink/paint to be extended (eg whether it is oil or water-based). The term is also (confusingly) applied to substances used to thin down overly thick inks to an appropriate consistency for printing.

Reduction method: process of making a multi-colour (or tonally graded) print from one block. The block is cut and printed in stages – each stage being overprinted on top of the preceding printing; between each printing, further cutting is carried out – thereby gradually reducing the block's uncut surface. It is also known as the **Suicide method** because no second thoughts are possible.

Registration: alignment of multiple printings onto the same surface to ensure that each printing falls in precisely the correct position relative to the last.

Registration board: implement to facilitate accurate registration.

Relief print/surface print: impression produced by applying ink to the surface of a printing plate. The block's uncut surface is the area which is printed; the cut (or indented) areas show as the colour of the printing paper.

Roller/brayer: tool used to roll out ink evenly onto inking slab and printing plate. It is also sometimes used for printing.

Roulette wheel: tool usually used on metal plates but useful for mark-making on various printing blocks. It comprises a tiny metal disc whose circumference is serrated with 'teeth'; this disc is attached to a slender handle by a central axle from which it rotates. Its 'teeth' impress minute regular indentations into the block's surface; these create both linear and tonal effects when inked and printed.

Sandbag/cushion: implement used in wood engraving; it comprises two circular pieces of leather sewn together and packed tight with sand. It is used as a surface on which to rest the block and is also used to facilitate the moving of block beneath tool rather than moving tool over block – a necessary part of the engraving procedure.

Scorper: tool for wood engraving. Its cutting tip is either squared off or rounded (called square or round scorpers accordingly). It is used to engrave square or round stippled marks, relatively broad lines, or to clear away large areas of a block's surface.

Screenprinting/serigraphy/ silkscreen: printing using a frame covered in a fine taut mesh through which ink is forced onto paper (or other material) beneath. Areas of the screen are masked off using refinements of stencilling techniques to define an image.

Separations: the drawing of each colour onto a separate sheet as an aid to block cutting.

Side-grain/long-grain: wood sawn in planks, along the grain. It is used for the technique of woodcutting in which the cuts made run parallel to the block's grain and the pattern of the grain is often (but not necessarily) a feature of the finished print.

Size: dimensions of image (or paper). Also gelatine or glue used to coat the fibres of a sheet of paper either internally or on the surface – to strengthen the paper and to facilitate its usage for either intaglio printmaking or watercolour painting respectively.

Spitsticker: wood engraving tool with a fine, sharp cutting edge and slightly rounded underbelly designed specifically to facilitate the engraving of curved lines. It can also be used to make fine stippled dots and straight lines of varying thicknesses.

Sponge pad: sponge soaked in ink or paint; small printers are pressed into the damp sponge as a method of inking.

Squeegee: straight piece of firm rubber or plastic mounted on a wooden handle; it is used to force ink through a mesh screen to create prints by the screenprinting process.

Stencil: template for a design involving cut-out shapes from (usually) stiff paper, card or acetate.

Stenocut: relief printing process using a thin rubbery material sold for use by stonemasons and signmakers.

Tint tool: wood engraving tool with an extremely fine cutting edge. It is used to make delicate lines of uniform thinness, or tiny stippled marks.

U gouge: lino or woodcutting tool with a cutting edge which is u-shaped in section. It is used to make broad marks and lines and to clear away large areas of the block's surface.

V gouge: lino or woodcutting tool with a cutting edge which is v-shaped in section. It is used to make fine marks and thin lines.

Waterleaf: pure, unsized paper.

Woodblock print: Western term for a traditional Japanese woodcut.

Woodcut: print produced from a block of side-grain wood or manufactured board.

Wood engraving: print produced from a block of endgrain wood using engraving tools.

Wove paper: term for many papers which, when held up to the light, show no distinctive mark as opposed to laid papers in which a clear pattern of the paper mould is visible.

Right *'Parzival's Castle', 297 x 227 mm, three-colour linocut on beige sugar paper, printed by roller-pressure. The artist was a nine year old pupil from Caersws School, Powys, Wales. This was his first linocut made during a children's workshop at Oriel 31, Newtown, Powys, Wales.*

Materials suppliers

Britain

Arboreta Papers
(papers, especially
recycled varieties)
Sargent Street
Bedminster
Bristol BS3 4BE
Tel. 0117 963 6699

Atlantis Art Materials Ltd
(art and conservation
supplies)
7/9 Plummer's Row
London E1 1EQ
Tel. 020 7377 8855

The Blast Shop
(stenocut materials)
S Critchley & Son
Agecroft Memorial Works
Langley Road
Pendlebury
Manchester M27 8SS
Tel. 0161 745 8071

R K Burt & Co
(paper)
57 Union Street
London SE1 1SG
Tel. 020 7407 6474

Anthony Christmas
(manufactured,
wood-substitute
engraving blocks)
15 Robertson Road
Buxton
Derbyshire SK17 9DV
Tel. 01298 78823L

Cornelissen & Son Ltd
(specialist printmaking supplies)
105 Great Russell Street
London WC1B 3RY
Tel. 020 7636 1045

Daler-Rowney Ltd
(general art supplies)
12 Percy Street
London W1A 2BP
Tel. 020 7636 8241

Ensinger Ltd
(delrin engraving blocks)
Unit D
Llantrisant Business Park
Llantrisant, Mid Glamorgan
CF7 8LF Wales
Tel. 01443 237 400

Falkiner Fine Papers
(paper, archival materials and
books on printmaking)
76 Southampton Row
London WC1B 4AR
Tel. 020 7831 1151

Green & Stone of Chelsea
(general art supplies)
259 Kings Road
London SW3 5EL
Tel. 020 7352 0837

Intaglio Printmaker
(specialist printmaking supplies
including Japanese woodcutting
materials and mail order)
62 Southwark Bridge Road
London SE1 OAS
Tel. 020 7928 2633

John Jones Art Centre Ltd
 (art supplies and framing)
 1 Morris Place
 London N4 3JG
 Tel. 020 7281 5439

T N Lawrence & Son Ltd
 *(specialist printmaking supplies,
 especially wood engraving and paper)*
 117 - 119 Clerkenwell Road
 London EC1R 5BY
 Tel. 020 7242 3534

T N Lawrence & Son Ltd
 38 Barncoose Industrial Estate
 Poole, Redruth
 Cornwall TR15 3RQ
 Tel. 01209 313 181

T N Lawrence & Son Ltd
 *(mail order available from
 Hove branch)*
 208 Portland Road
 Hove, East Sussex BN3 5QT
 Tel. 01273 260 260

Nairn Floor Ltd *(lino)*
 P.O. Box 1, Kirkcaldy
 KY1 2SB Scotland
 Tel. 01592 643 111

Paintworks Ltd
 *(paper and basic printmaking
 supplies and mail order; also
 specialist framer of artists' prints)*
 99 - 101 Kingsland Road
 London E2 8AG
 Tel. 020 7729 7451

John Purcell Papers
 (specialist printmaking papers)
 15 Rumsey Road, Stockwell
 London SW9 OTR
 Tel. 020 7737 5199

Reeves Art Materials
 *(general art materials:
 paper specialists)*
 178 Kensington High Street
 London W8 7RG
 Tel. 020 7937 5370

Reeves Art Materials
 P.O. Box 91
 Whitefriars Avenue
 Wealdstone
 Harrow
 Middlesex HA3 5RH
 Tel. 020 8427 4343

Rollaco
 (specialist printmaking rollers)
 72 Thornfield Road
 Middlesbrough
 Cleveland TS5 5BY
 Tel. 01642 813 785

Shepherds Bookbinders Ltd
incorporating
Sangorski, Sutcliffe
and Zaehnsdorf
 *(bookbinding and paper
 conservation products)*
 76 Rochester Row
 London SW1P 1JU
 Tel. 020 7630 1184

Specialist Crafts Ltd
 *(general arts and crafts
 especially for children)*
 P.O. Box 247
 Leicester LE1 9QS
 Tel. 0116 251 0405

Stuart R Stevenson
 (gilding materials)
 68 Clerkenwell Road
 London EC1M 5QA
 Tel. 020 7253 1693

Alec Tiranti
(sculpture materials including clays)
70 High Street
Theale, Reading
Berks RG7 5AR
Tel. 01189 302 775

Yorkshire Printmakers
& Distributors
(specialist printmaking supplies)
26 - 28 Westfield Lane
Emley Moor, Nr Huddersfield
Yorkshire HD8 9TD
Tel. 01924 841 514

USA

American Printing Equipment
& Supply Co.
(printmakers' supplies)
42 - 25 9th Street
Long Island City
New York 11101-491
Tel. +718 417 3939

Apex Printers Rollers Co.
(printing rollers)
1541 North 16th Street
St. Louis, Missouri
Tel. +314 231 9752

The Art Store
(general supplies)
1 - 5 Bond Street between
Broadway and Lafayette
New York
Tel. +212 533 2444

Atlantic Papers
1800 Mearns Road
Suite P, Ivyland
PA 18974
Tel. 800 367 8547

Atlantic Papers
1A Triphammer Lane, Ithaca
New York 14850 - 2503
Tel. 1 800 367 8547

Baggot Leaf Co.
*(gilding supplies and
metallic pigments)*
430 Broome Street
New York
Tel. +212 431 4653

Sue Anne Bottomley
*(sample stenocut plates
and US stenocut sources)*
5246, Wildflower Terrace
Columbia, Maryland 21044
Tel. +410 740 3285

Dave Churchman
(Sterling Type Foundry)
7830 Ridgeland Drive
Indianapolis
IN 46250
Tel. +317 849 1616

Dieu Donne Paper Mill
(handmade papers)
433 Broome Street
New York
Tel. +212 226 0573

Dolphin Papers
1125 Brookside Avenue
G-900
Indianapolis
IN 46202
Tel. 800 346 2770

Garrett-Wade Co. Inc.
(wide range of woodcutting tools)
161 Avenue of the Americas
New York
Tel. +212 807 1155

Graphic Chemical and Ink Co.
 P.O. Box 27
 728 North Yale Avenue
 Villa Park
 Illinois 60181
 Tel. +708 832 6004

The Green Drop Ink Co.
 (water-based printing inks)
 2 Cornhill Drive
 Morristown
 New Jersey 07960
 Tel. 973 402 6070

Kate's Paperie *(papers)*
 561 Broadway at Prince Street
 New York
 Tel. +212 941 9816

Kate's Paperie
 8 West 13th Street
 New York
 Tel. +212 633 0570

Light Impressions Corp.
 (archival storage materials)
 P.O. Box 3012
 Rochester
 New York
 Tel. +716 271 8960

Edward C Lyons
 (wood engraving tools)
 3646 White Plains Road, Bronx
 New York 10467
 Tel. +718 515 5361

McClain's Printmaking Supplies
 *(wood engraving, Japanese
 and general printmaking
 supplies and mail order)*
 P.O. Box 40163, Portland
 OR 97240-0163
 Tel. 1 800 832 4264

Mohawk Paper Mills, Inc.
 P.O. Box 497, Cohoes
 New York 10003
 Tel. 1 800 843 6455

Na Graphics *(letterpress supplies)*
 P.O. Box 467, Silverton
 CO 81433
 Tel. 970 387 0212

New York Central Art Supply
 (paper and printmaking supplies)
 62 3rd Avenue, New York
 Tel. +212 473 7705

The Paper Source
 2112 Central Street
 Evanston, Illinois
 Tel. +847 733 8830

Paper Technologies, Inc.
 929 Calle Negocio
 Unit D, San Clemente
 CA 92673
 Tel. 800 727 3716

Pearl Paint Co.
 *(general art supplies
 and mail order)*
 308 Canal Street
 New York
 Tel. +212 592 2179

Persighin-Sparks
 Planographic Roller Co.
 1900 Robinwood Road
 Baltimore MD 21222
 Tel. 800 474 1213

PONDIpaper Handmade Indian
 Distributor: Stewart J. Thomas
 229 Southeast 8th Street
 Gainesville FL 32601-6929
 Tel. +352 372 0449

The Printer's Shopper
 (General Supplies)
 111 Press Lane, Chula Vista
 CA 91910 - 1093
 Tel. 1 (800) 854 2911

Rembrandt Graphic Arts
 (printmakers' general supplies)
 P.O. Box 130, Rosemont
 New Jersey 08556
 Tel. +609 397 0068

Jim Reynolds
 (good maple blocks for
 engraving, will resurface)
 2168 N. 58th Street
 Milwaukee
 WI 53208
 Tel. +414 771 1377

David Sander & Co.
 (printmakers' general supplies)
 602 W. Morgan Avenue
 Chesterton
 IN 46304-1551
 Tel. +219 929 1551

Savoir Faire Art Materials
 Renaud Lhomme
 P.O. Box 2021, Sausalito
 CA 94966
 Tel. +415 332 4660

Sculptors' Supplies Co.
 (wood carving tools)
 242 Elizabeth Street
 New York
 Tel. +212 334 3272 / +212 673 3500

Sculpture Supply Co.
 (wood carving tools)
 220 East 6th Street
 New York
 Tel. +212 673 3500

Daniel Smith Inc.
 (mail order paper, inks
 and general supplies)
 4150 1st Avenue South
 P.O. Box 84268
 Seattle
 Washington 98124-5568
 Tel. +206 223 9599

Takach Press Corporation,
 (specialist printmaking
 supplies)
 3207 Morningside NE
 Albuquerque
 NM 87110
 Tel. +505 242 7674

Twinrocker Handmade Paper
 P.O. Box 413
 Brookston
 IN 47923
 Tel. +765 563 3119

TW Graphics Group
 (water-based silkscreen ink)
 7220 E. Slauson Avenue
 City of Commerce
 CA 90040
 Tel. 800 247 5589

Utrecht Art Supply
 (general supplies)
 111 Fourth Avenue between
 11th and 12th Streets
 New York
 Tel. +212 777 5353

Arjo Wiggins Speciality Papers
Linda Laska Promo. Manager
 P.O. Box 220
 21 Industrial Drive
 South Hadley
 MA 01075
 Tel. 800 252 2211

Zellerbach, A Mead Paper Co.
 (paper)
 245 South Spruce Avenue
 South San Francisco
 Tel. +650 589 5577

Australia

Art Papers *(paper)*
 243 Stirling Highway
 Claremont
 Western Australia 6010
 Tel. +618 9384 6035

Artistcare
 (fine and graphic art supplies)
 276 Park Street
 South Melbourne, Victoria
 Tel. +613 9699 6188

Artsup *(printmaking supplies)*
 Shop 7, Manning Street
 Kingswood 2747, Sydney
 New South Wales
 Tel. +612 4736 5866

Atos Art Supplies
 (graphic supplies)
 3 Chard Road, Brookvale
 Sydney, New South Wales
 Tel. +612 9939 7633

Canson *(artists' papers)*
 2/9 Clarice Road
 Box Hill, Melbourne, Victoria
 Tel. +613 9899 9833

CDK Stone
 (stenocut supplies)
 Unit 21, 260 Wickham Road
 Moorabbin, Melbourne
 Victoria 3189
 Tel. +613 9553 3055

Eckersley's
 (art and print supplies)
 93 York Street
 Sydney
 New South Wales
 Tel. +612 9299 4151

97 Franklin Street
 Melbourne
 Tel. +613 9663 6799

Cnr Edward and Mary Sts
 Brisbane, Queensland
 Tel. +617 3221 4866

21-27 Frome Street
 Adelaide
 Tel. +618 8223 4155

Expressions Art
 (paper)
 P.O. Box 2095
 Kew, Victoria
 New South Wales
 Tel. +613 9853 6435

Janet's Art Supplies
 *(printmaking books,
 materials and mail order)*
 145 Victoria Avenue
 Chatswood, Sydney
 New South Wales 2067
 Tel.+612 9417 8572

Jacksons
 (fine art and etching supplies)
 103 Rokeby Road, Perth
 Tel. +618 9381 2488

Magnani Papers Australia
 (paper)
 53 Smith Street
 Fitzroy, Victoria 3065
 Tel. +613 9417 3736

Melbourne Etching Supplies Ltd
 (specialist printmaking supplies)
 33A St David Street
 Fitzroy, Victoria 3065
 Tel. +613 9419 5666

The Student Supply Shop
 (paper and printmaking supplies)
 Old College of Art, Cnr Foxton
 Street and Clearview Terrace
 Morningside, Brisbane
 Queensland 4170
 Tel. +617 3399 3363

Oxford Art Supplies
 (fine and graphic art supplies)
 221-223 Oxford Street
 Darlinghurst, New South Wales
 Tel. +612 9360 4066

Premier Art Supplies
 (art and print supplies)
 43 Gilles Street
 Adelaide
 Tel. +618 8212 5922

Parkers Sydney Fine Art Supplies
 (art and etching supplies)
 Cnr Argyle and Cambridge Sts
 The Rocks, Sydney
 New South Wales
 Tel. +612 9247 9979

Tamarisque Fine Art
 (paper)
 27 Albion Street
 Surrey Hills
 Sydney, New South Wales
 Tel. +612 9212 1223 Art

ACKNOWLEDGEMENTS

The authors would like to thank the following for permission to reproduce their works: Carolyn Abbott; Dale Devereux Barker; Lancillotto Bellini; Mandy Bonnell; Sue Anne Bottomley; The British Museum; Greig Burgoyne; Stacey Chapman; Susan Conti; Louisa Desmet; Edwina Ellis; Amy English; Katy English; Anne Gilman; Caroline Glicksman; Penny Grist; Max Halstead; Sarah Hamilton; Fiona Hamley; Ellen Hanceri; Magnus Irvin; Elaine Kowalsky; Peter Lazarov; Jean Lodge; Ken Mahood; Saša Marinkov; Stephen Mumberson; Hester Pelly; Monica Poole; Suzanne Roles; Rebecca Salter; Sally Stephens; Sandy Sykes; Joan Vere; Roy Willingham; Thomas Willingham; and Judy Willoughby. The authors are also indebted to:

Roy Willingham; Irene Desmet; Jackie Newell; Diane Miller; Tiffany McNab; Pauline Muir and Jim Todd for their invaluable assistance and support. Thanks also go to Louisa Desmet; Max Halstead; Ken Mahood; Stephen Mumberson; Jean Lodge and Roy Willingham for preparing prints especially for this book; to Sue Anne Bottomley, Edwina Ellis, Fiona Hamley and Rebecca Salter for their specialist advice on stenocut, delrin engraving, caustic soda etch and baren printing respectively; to Intaglio Printmaker Ltd and to Paintworks Ltd (both of London) for providing materials and equipment which were used to produce artworks for this book; and to Joss Reiver Bany for photographic services.

Bibliography

Aston, Maggy
Printing with modelling clay.
Printmaking Today Vol. 7 No. 3
pp. 26–7. Farrand Press,
London 1998.

Biggs, John R
*Classic Woodcut Art
and Engraving.*
Blandford Press – an imprint of
Cassell plc, London 1958, 88
and 89 (distributed in US by
Sterling Publishing Co. Inc,
New York and in Australia by
Capricorn Link Pty Ltd., NSW).

Bottomley, Sue Anne
Stenocut. Printmaking Today
Vol. 3 No. 4 pp. 24–5, 1994 &
Vol. 4 No. 1 p. 29,
Farrand Press, London 1995.

Brett, Simon
Wood Engraving – How To Do It.
Primrose Hill Press (2nd edition),
London 2000.

Chamberlain, Walter
*The Thames & Hudson Manual
of Wood Engraving.*
Thames & Hudson,
London 1978.

Digby, John & Joan
The Collage Handbook.
Thames & Hudson,
London 1985.

Erickson, Janet Doub
& Sproul, Adelaide
Print Making without a Press.
Art Horizons Inc. Reinhold,
New York 1966.

George, Jon
Cast printing.
Artists Newsletter p. 29.
Artic Publications,
UK February 1994.

George, Jon
Castprinting: A new method.
Printmaking Today Vol. 4 No. 1
pp. 26–7, Farrand Press,
London 1995.

Jerstorp, Karin & Kohlmark, Eva
The Textile Design Book.
Lark Books, North Carolina
USA; & A & C Black,
London 1988.

Larbalestier, Simon
The Art and Craft of Montage.
Mitchell Beazley International
Ltd, London 1993.

Martin, Judy
*The Encyclopedia of
Printmaking Techniques.*
Quarto, London 1993.

Oravez, David L
Woodcut.
Watson-Guptill, New York 1992.

Salter, Rebecca
Japanese Wood Block Printing.
A & C Black, London 2001.

Scott, Paul
Ceramics and Print.
A & C Black, London 1994.

Simmons, Rosemary
& Clemson, Katie
*The Complete Manual
of Relief Printmaking.*
Dorling Kindersley,
London 1988.

Smith, Lawrence
The Japanese Print since 1900.
British Museum Press, 1983.

Smith, Lawrence
*Modern Japanese Prints
1912–1989.*
British Museum Press, 1994.

Stobart, Jane
Printmaking for beginners.
A & C Black, London 2000.

Tofts, Hannah
The Print Book.
Two-Can, London 1989.

Vollmer, April
*Moku Hanga: traditional
Japanese woodcut.*
Printmaking Today Vol. 7 No. 4
pp. 26–7, Farrand Press,
London 1998.

Walklin, Colin
Relief Printmaking.
The Crowood Press,
Wilts UK 1991.

Westley, Ann
Relief Printmaking.
A & C Black, London 2000.

THE AUTHORS

Anne Desmet and Jim Anderson are practising artist-printmakers. Anne specializes in wood engraving, linocut, mixed-media collage techniques and artist's books which she prints both with and without a press. Jim's areas of interest include linocut, collagraph, screenprint, drypoint, mixed-media, paper-making and mosaic production; in all of his artforms, recycling found materials is a priority. Anne is a former lecturer in printmaking at several undergraduate and postgraduate institutions including the Royal Academy Schools, London. Jim is a former teacher, at secondary school level, of art history and printmaking. Both exhibit widely, have won awards for their prints and have works in both public and private collections worldwide. At just 34 years old, Anne Desmet had a major retrospective exhibition at the Ashmolean Museum, Oxford (and touring UK) in 1998-9. She is also editor of *Printmaking Today* – a quarterly journal of international contemporary graphic art.

Anne Desmet

Jim Anderson

Index